IMAGES
of America

GUARDING
NEW JERSEY'S SHORE
LIGHTHOUSES AND
LIFE-SAVING STATIONS

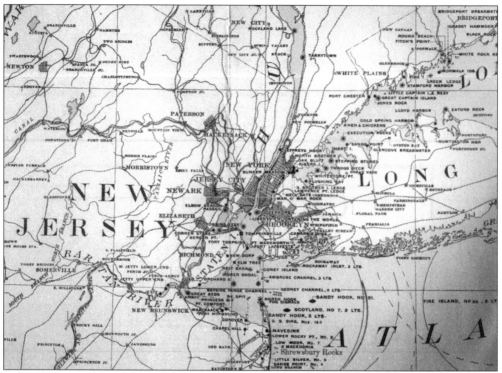

This map from the Lighthouse Service annual report shows the New Jersey lights in 1900. In 1852, the country was divided into 12 lighthouse districts. New Jersey, originally in the fourth district, was later divided between the third and fourth districts. Still later, in the Coast Guard era, the state was divided between the third and fifth districts, with the Shrewsbury River as the boundary. The third district is north of the river. (Coast Guard.)

IMAGES
of America

GUARDING
NEW JERSEY'S SHORE
LIGHTHOUSES AND
LIFE-SAVING STATIONS

David Veasey

ARCADIA

First printed in 2000

Published by Arcadia Publishing,
an imprint of Tempus Publishing, Inc.
2 Cumberland Street
Charleston, SC 29401

Printed in Great Britain.

Library of Congress Catalog Card Number: 00-101193

For all general information contact Arcadia Publishing at:
Telephone 843-853-2070
Fax 843-853-0044
E-Mail sales@arcadiapublishing.com

For customer service and orders:
Toll-Free 1-888-313-2665

Visit us on the internet at http://www.arcadiaimages.com

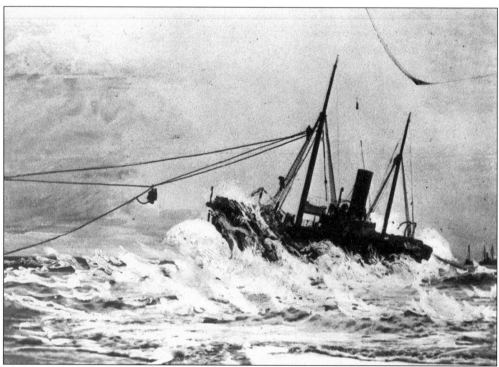

If ships did not wreck, there would be no need for towering lighthouses and life-saving stations. In 18th- and 19th-century parlance, a shipwreck was anything from a stranding that lasted until the next high tide to a full-scale disaster killing hundreds as a ship was pounded to pieces by the fury of the waves. Those who went to the aid of stricken ships in the 18th and 19th centuries, before the Life-Saving Service, were known as wreckers. (Coast Guard.)

CONTENTS

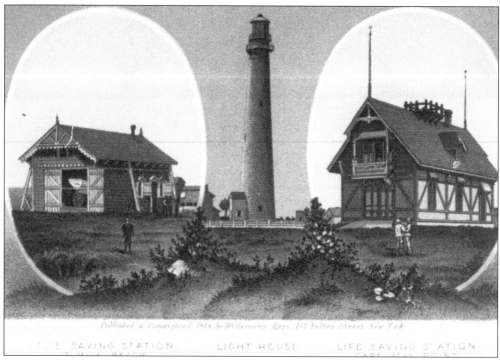

LIFE SAVING STATION. LIGHT HOUSE LIFE SAVING STATION

The lighthouse and life-saving stations of Cape May (1889) epitomize the 19th-century attempts along the New Jersey shore to protect people from the unforgiving ocean. (Cape May Historical and Genealogical Society.)

ACKNOWLEDGMENTS

This book could not have been done without the active cooperation of the U.S. Coast Guard, especially Dr. Robert Browning, the Coast Guard historian, and Dr. Peter Capelotti of the historian's office in Washington, D.C. I also want to thank the Coast Guard Public Affairs offices in New York City and Portsmouth, Virginia; the Aids to Navigation team at Cape May; and the Civil Engineering Group in Providence, Rhode Island. Thanks also to Elizabeth Bailey at the Mid-Atlantic Center for the Arts in Cape May; Julie Senack of the Atlantic City Free Public Library; the Inlet Public-Private Foundation; the operators of Absecon Light; Paul Anseln at the Ocean City Historical Museum; Janet Ravolta at the Ocean County Historical Society; Tom Laverty at Twin Lights State Park; other state park employees at Island Beach, Barnegat, Cape May Point, and Fort Mott; T.J. MacMahon of Fair Haven; and Crystal Carrafiello of Wayne. I also want to thank staffers at the National Archives in Washington, D.C., and College Park, Maryland. All pictures are credited with an assumed "courtesy of."

This book is dedicated to my wife, Dorothy, my son, Jeffrey, and my daughter, Robyn, who accompanied me—sometimes less enthusiastically than other times—to lighthouses and life-saving stations from Maine to Maryland, but especially "Down the Shore."

INTRODUCTION

Barnegat Light, the state's best-known lighthouse and its unofficial symbol, stands today as a silent guardian from the era when sailing ships and early steamships foundered on New Jersey's treacherous coast. While the state's other lighthouses may not be as prominent, they played important roles in maritime safety and introduced many innovations in lighthouse technology. New Jersey lighthouses were tourist attractions, too. Indeed, the lighthouse in Atlantic City, officially known as Absecon Light, was the most visited lighthouse in the country at the start of the 20th century, logging in more than 10,000 visitors during the summer.

Twin Lights at Navesink garnered a number of firsts, including the first use of a modern French-designed Fresnel lens in 1841. It was also the first lighthouse to use electricity in 1898 and the site for early experiments in radio and radar. In 1917, it was the site used to test radio for navigation.

Long before the popularity of women's rights, three New Jersey lighthouses were kept by women at various times. Kate Walker was the head keeper at Robbins Reef from 1886 to 1919. Elizabeth MacCashin was head keeper at the now long-forgotten Passaic Lighthouse from 1901 to 1914. Hannah McDonald served as head keeper of Bergen Point from 1873 until 1879. Also, a number of women served as assistant keepers even though they were not related to the head keeper.

At one time New Jersey had thirty-six lighthouses and six lightships from New York Harbor south along the coast to the Delaware Bay and up the Delaware River to Philadelphia. Eighteen of those lighthouses remain.

It is hard to remember that the New Jersey shore was a perilous coast well into the 20th century. The rural shore was the site of more than 1,000 documented wrecks, although thousands of other ships may have been stranded or wrecked on these shores from the 1600s onwards before accurate records were kept. It was the blinking and fixed lights piercing the night sky along the coast that gave direction and solace to mariners bound for New York or Philadelphia. It is New Jersey's fate, as allegedly observed by Benjamin Franklin, to be like a barrel tapped at both ends because of its location between New York and Philadelphia. The state's proximity to both major ports led to the early placing of lighthouses and lightships guarding our waters. Much later, the U.S. Life-Saving Service—a forerunner of the U.S. Coast Guard—evolved into a national organization of at least 275 stations from its 8 original stations located Down the Shore in 1848. For most of the history of the United States, the Life-Saving Service of New Jersey had 41 stations. For a period, there was also a 42nd station near what is

now the ferry dock in Cape May. Approximately 20 life-saving stations remain, although some have been altered dramatically.

A rising toll of shipwrecks accompanied the burgeoning coastal and international trade after the American Revolution, and especially after the War of 1812. This increase led the new federal government, marine insurers, merchants, and shipping interests to increase safety aids to mariners. The efforts of these groups included building more lighthouses, charting the coasts, regulating pilot services, publishing sailing directions for the coasts and their ports, and making some basic provisions for rescuing stranded ships—if not their passengers and crew.

New Jersey's flat, low-lying coast, without harbors of refuge, was especially treacherous. Danger lurked in the shoals several hundred yards offshore, running along most of the coast's 127 miles, and in its arms jutting into the sea at Sandy Hook and Cape May. A glance at a navigational chart shows why: as ships followed a coastal route north or south in the Age of Sail, winds blowing toward the land could easily drive vessels onto those shoals.

Cape Hatteras on the Outer Banks of North Carolina is often called the Graveyard of the Atlantic. However, a truer graveyard of the Atlantic is New Jersey's coast. More shipwrecks have been documented here than at Cape Hatteras, according to shipwreck data in the Life-Saving Service's annual reports for the 25 years between 1887 and 1911. During that period, New Jersey recorded 1,257 shipwrecks while North Carolina had 916.

After the federal government formed in 1789, the ninth law passed by Congress, on August 7, gave responsibility for lighthouses to the central government; shortly afterward, that responsibility was assigned to the secretary of the treasury.

Lighthouses span the nation's history, from the still-operating Sandy Hook Light of the Colonial period to the new Ambrose Tower, erected in 1999. But today's lighthouses are more than living history memorials. Coastal lights are marvels of 19th-century technology. They are that century's skyscrapers.

Lighthouses, as defined for this book, are structures that require a staff to maintain the lighting apparatus. The emphasis is on the period prior to 1939, when the Lighthouse Service became part of the U.S. Coast Guard. Lighthouses and life-saving stations are presented from north to south, with the exception of Sandy Hook. Included are several lighthouses or lightships that are in either New York or Delaware but that also serve as aids to navigation to New Jersey ports.

The book begins with Sandy Hook, the nation's oldest lighthouse still in operation, moves to the Statue of Liberty in New York Harbor, officially a lighthouse from 1886 to 1901, and ends in the Delaware River south of Philadelphia. The same organizational scheme is followed for life-saving stations, beginning in the north at Sandy Hook and following the state's Atlantic Coast to its end at Cape May Point.

Although it is relatively easy to view the state's remaining land-based lighthouses, tracking down the former life-saving stations is a far more daunting task. Stations changed names and locations, or they changed locations without changing names. The designations in the book reflect names assigned to stations by the Life-Saving Service in 1900, a few years before the merger with the Revenue Cutter Service, in January 1915, to form the U.S. Coast Guard.

One

U.S. LIGHTHOUSE ESTABLISHMENT

Before American independence, lighthouses were the responsibility of each colony and built to meet local needs without any thought to overall navigation. When the federal government was formed, there were only 11 lighthouses in the country. By 1820, when the responsibility for lighthouses was in the hands of the Treasury Department's fifth auditor, Stephen Pleasonton, there were 55 lighthouses, with 3 of them in New Jersey.

Pleasonton's Scroogelike management led to vociferous complaints about the poor quality of U.S. lights from shipowners and sea captains. Finally, in 1851, Congress ordered a thorough investigation of U.S. lights compared to European ones. A scathing report denouncing U.S. lights was issued in 1852. This important document will be referred to throughout this book as the 1852 Report.

In the wake of the investigation, responsibility for lighthouses was taken away from the fifth auditor and given to a newly created Lighthouse Board, still within the U.S. Treasury Department. The new Lighthouse Board was made up of two naval officers, two army engineers, and two civilians of "high scientific attainment." This system lasted until 1903, when the Lighthouse Board was transferred to the newly formed Department of Commerce and Labor, a change made partially to lessen military influence on the lighthouse service and partially to consolidate all maritime-related agencies in one department. In 1910, the Lighthouse Board was abolished and replaced by the Bureau of Lighthouses, headed by George R. Putnam. The Lighthouse Service merged with the Coast Guard on July 7, 1939.

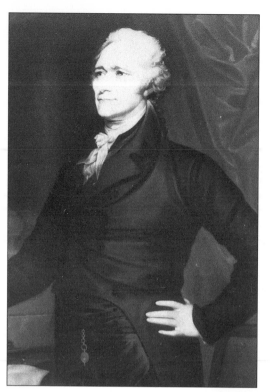

Alexander Hamilton, the first secretary of the treasury, founded the Revenue Marine Service (in 1863, the name changed to the Revenue Cutter Service), one of the two original organizations that came together to form the U.S. Coast Guard. His department was also responsible for collectors of Customs as supervisors of lighthouses in their districts, which in New Jersey were at Perth Amboy, Egg Harbor, and Somers Point.(Coast Guard.)

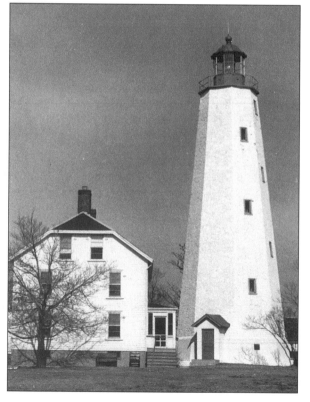

Sandy Hook, as it looked c. 1950, would simply be a picturesque tower by the sea if it did not have a source of illumination and a means to magnify the light so that it was visible at sea. A light by itself is difficult to interpret without referring to a nautical chart and the Light List, a government publication first published in 1838. The Light List explains the particular hazard or reason for the lighthouse. (Coast Guard.)

Early U.S. lighthouses used candles for illumination, followed by spider lamps with four or so wicks floating in a pan of sperm whale oil. Wicks had to be trimmed to be effective, and lighthouse keepers came to be known as "wickies." Spider lamps were used until the War of 1812. The lamps were housed in the lantern, the metal frame structure with glass panes at the top of the tower, illustrated by Twin Lights in an 1862 architectural rendering. (National Archives.)

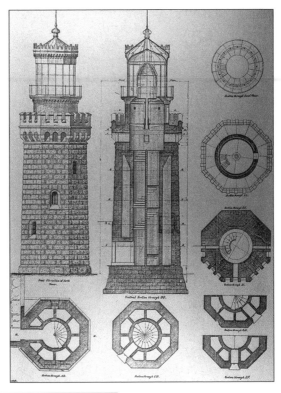

The Argand lamp, developed in England in 1781, was the next lighting advance. It featured a hollow circular wick that allowed oxygen to pass inside and outside the wick, increasing the fire's intensity and making a smokeless flame. The lamp was also fitted with parabolic reflectors to magnify the light. Winslow Lewis's adaptation of the Argand lamp was used in this country. (Coast Guard.)

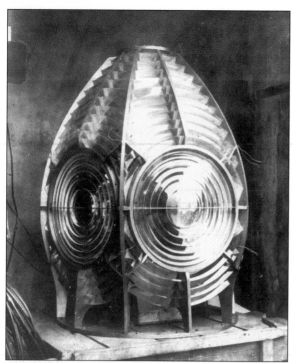

The fourth-order Fresnel lens was one of the lenses invented in 1822 by Augustin Fresnel, a French physicist. Beehive-shaped glass prisms surrounded the lamp, refracting and shaping the light at the top and bottom. The light was magnified by the bulls-eye glass panels in the midsection, thus casting a brilliant and concentrated beam of light. Fresnel lenses are made in seven orders or sizes, with the first order for primary seacoast lights (about 8 feet tall) down to the sixth order (about 18 inches tall) that may have marked a pier. (Coast Guard.)

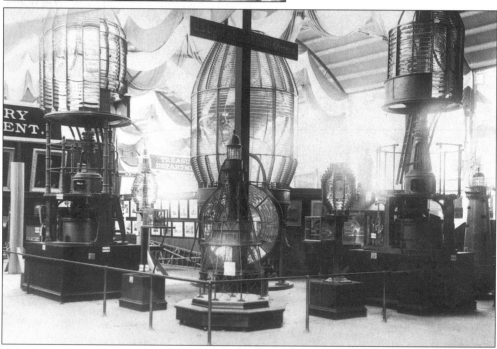

This array of lenses was on display at the Lighthouse Services exhibit at the 1893 Columbian World Exposition in Chicago. The 1852 Report noted that Fresnel lenses were over four times more brilliant and effective than the best reflector system and used about 25 percent less sperm oil. Each lamp at Atlantic Coast lighthouses burned about 32 gallons of sperm oil annually. A lighthouse could have 30 lamps. (National Archives.)

The Staten Island lighthouse depot, shown with an employee in 1912, tested all oil and other materials before they were sent to lighthouses. As the price of sperm oil kept rising, the Lighthouse Service experimented with rapeseed oil and gas lamps, and also tried vegetable oil and lard. The latter was used until the 1870s when mineral oil or kerosene was introduced. (Coast Guard.)

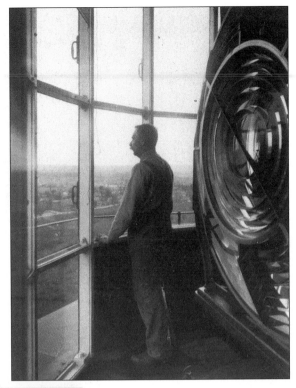

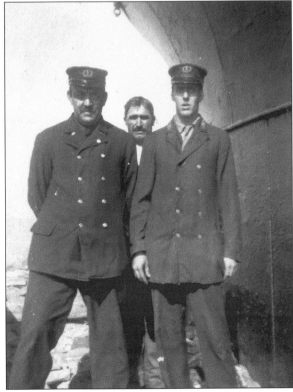

Lighthouse keepers, like these three from West Bank Lighthouse in the New York-New Jersey harbor, were political appointees. After 1852, however, standards and rules were put into effect. Lighthouses had between one to four keepers who, after 1896, fell under Civil Service regulations. This December 1916 photograph shows, from left to right, Julius Johansen, Simon Sfvorinich, and head keeper Millard Caler. (National Archives.)

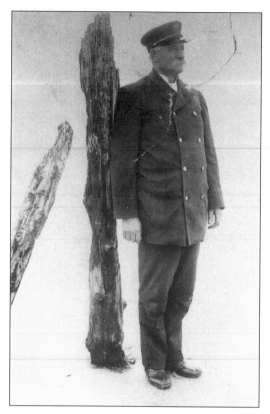

From 1888 to 1915, James Eldredge was the keeper of Cape May Lighthouse. He is shown here in 1909. It was his job, like all keepers, to maintain the light. The light was expected to be ready by 10:00 a.m. to be lighted at sunset that evening and extinguished at sunrise. By 1915, the written list of instructions to keepers ran to 51 pages, encompassing 161 instructions. (Cape May Historical and Genealogical Society.)

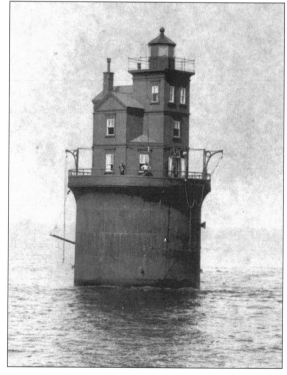

Albert Einstein was alleged to have remarked that every young man should spend time as a lighthouse keeper—such as on the isolated Fourteen-Foot Bank in Delaware Bay, shown in 1912—in order to have time to think. While this seems romantic, one young Coast Guardsman described his stint at Fourteen-Foot Bank as one of boredom and isolation, and said that he felt like a stranded sailor. Although he was single, keeping the light could be a family affair, with wives and children helping out. (National Archives.)

Two
NEW JERSEY-NEW YORK
HARBOR LIGHTS

The harbor serving New Jersey and New York is the nation's leading port, and although an ideal port in many respects, it is handicapped by an offshore, underwater sandbar that extends from Sandy Hook across the outer harbor to the tip of Coney Island, cutting the depth or clearance above the shifting shoals to only 24 feet at low tide.

It was never preordained that New York Harbor would become the country's leading port, although by 1797 it had reached that position, just ahead of Boston and Philadelphia. After the War of 1812, burgeoning trade and the opening of the Erie Canal in 1825 pushed the New York port even further ahead of potential rivals.

The Main Channel, or Sandy Hook Channel, was the primary approach to New York Harbor, a route that skirts Sandy Hook peninsula; hence, the earliest lighthouse was located there. It was the only route to New York Harbor that avoided going through Long Island Sound until 1839 when Lieutenant Gedney of the Coast Survey discovered the channel that now bears his name.

As the volume of shipping and trade increased, other lighthouses were built in New York Harbor: North Beacon Sandy Hook (1817), Robbins Reef (1839), Great Beds (1889), Old Orchard Shoal (1893), Romer Shoal (1898), and West Bank Lighthouse (1901).

In 1903, a third major approach was created with the dredging of Ambrose Channel, making it the preferred entrance to New York. This meant shifting the Sandy Hook lightship to a new position and renaming it *Ambrose Lightship*. The region's newest lighthouse, erected in September 1999, stands not far from where the lightship was once anchored.

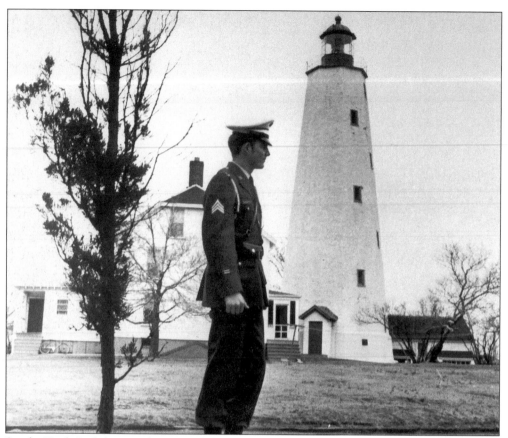

Sandy Hook Lighthouse, shown *c.* 1950, is the nation's oldest operating lighthouse. It was originally known as New York Lighthouse, standing on what was once the northern tip of the Sandy Hook peninsula. A military presence has been there almost since the lighthouse was built. The lighthouse was sponsored by New York City merchants and shipowners and was paid for by two lotteries, with its ongoing expenses covered by a 22¢ tonnage tax on all ships entering the port. (Rutgers University Libraries Special Collections.)

Sandy Hook began its daily vigil on June 11, 1764, and initially was lighted by 48 oil blazes. Shown in its earliest known picture from the August 1790 issue of *New York Magazine*, the lighthouse was 103 feet tall and was built by Isaac Conro. The 1852 Report reaffirmed the importance of the light, stating that "Sandy Hook main light, and the two beacons adjacent, serve as the principal guide to pilot and navigators leading from the sea to New York Bay." In 1857, the lighthouse had a third-order lens. (Rutgers University Libraries Special Collections.)

The approximately 7-mile Sandy Hook peninsula had two other lighthouses built in 1817 that served as range lights when lined up with buoys. Eventually, they became known as the north and south beacons. The north beacon, shown in this contemporary scene by the George Washington Bridge where it was moved in 1917, later became famous in *The Little Red Lighthouse*, a popular children's story. (New York City Department of Parks and Recreation.)

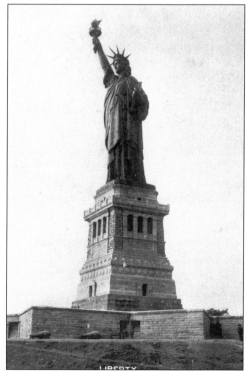

Even the Statue of Liberty was pressed into lighthouse service. Its torch not only welcomed the "huddled masses" but also was officially listed as an aid to navigation from 1886 (the year of this photograph) to 1901. The electric light in the torch of Liberty's upraised arm was 305 feet above the water, and power was supplied by a generator at the base, making it the first use of electricity in the Lighthouse Service. High operating and maintenance costs ended Lady Liberty's lighthouse career. (National Archives.)

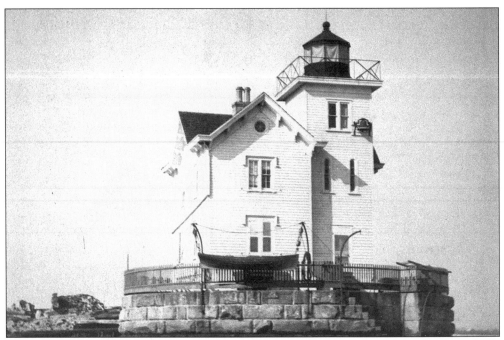

The Passaic Lighthouse, shown above in 1885, marked the junction of Newark Bay and the Passaic River and warned of nearby mud flats. It was built in 1849 and was rebuilt in 1859. It had a fifth-order lens mounted 46 feet above sea level. In the early 1930s, newspapers ran stories about the hermit of Passaic Lighthouse, Hugh MacCashin. MacCashin was the son of Elizabeth MacCashin, the light's last keeper, who took over after her husband's death in 1903 and served until her own death in 1914. That year, the lighthouse was closed because the river channel had shifted. From then on, the son lived alone in the abandoned lighthouse and was paid $1 a year as a custodian. He once asked a *Newark Evening News* reporter why anyone would want to write about him, "a lighthouse keeper without a light." The photograph below shows the abandoned lighthouse in the early 1930s. (National Archives, above; Newark Public Library, below.)

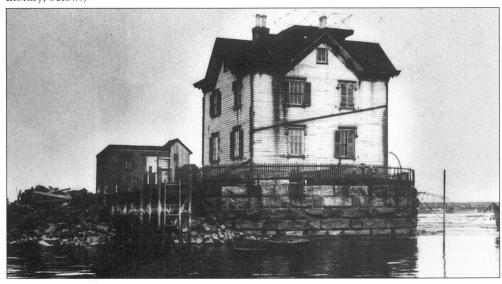

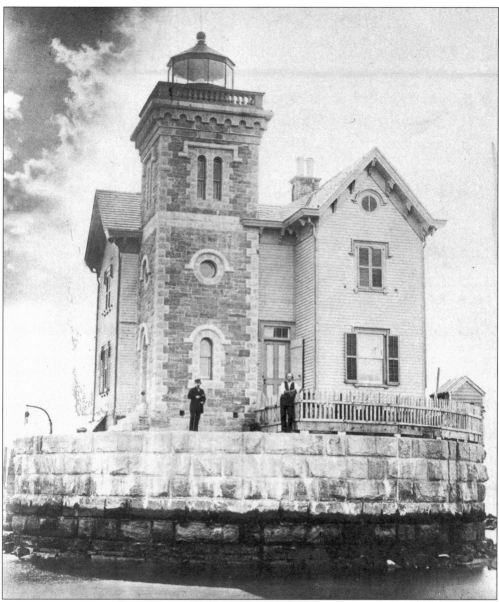

Bergen Point Lighthouse, shown above in 1900, was originally built in 1849. Similar in design to Passaic Lighthouse, it marked a rocky reef at the entrance of the Kill van Kull into Newark Bay, off the coast of Bayonne. The lighthouse was rebuilt in 1859 for $5,000. An 1853 investigation of the earlier lighthouse reported that "the house is settled at the center and even admitting the foundations to be good, it is doubtful whether it would be proper to attempt any repairs." Hannah McDonald served as head keeper of Bergen Point from 1873, when her keeper husband died, to 1879. In 1915, the light was described as a fourth-order lens 46 feet above the water. The lighthouse operated until 1948 when the channel was dredged and changed. It was torn down and replaced by buoy 12A, shown at the right. (National Archives.)

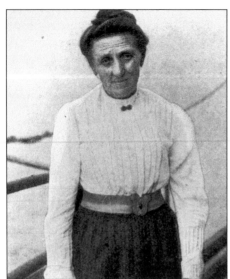

Kate Walker, shown in 1909, is the most famous lighthouse person in the New Jersey and New York area. She worked as head keeper at Robbins Reef from 1894 to 1919, retiring at age 73. She replaced her husband, John Walker, who died and whose last words to her were reportedly, "Mind the light, Katie." Although she was less than 5 feet tall and weighed under 100 pounds, her granddaughter told newspaper reporters years later that Kate rescued about 50 people, mostly fishermen. (Coast Guard.)

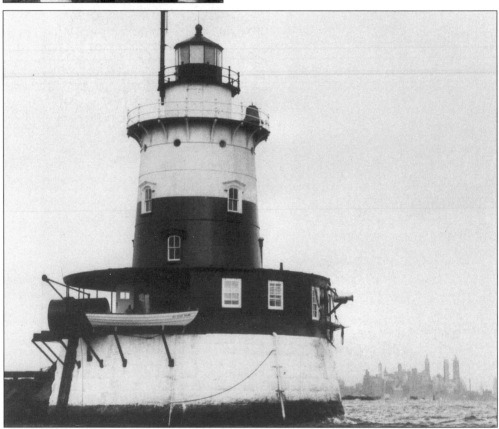

Kate Walker's light was Robbins Reef, shown c. 1950. Rob is an old Dutch word for seal. The light station was established in 1839 and was rebuilt in 1883. It warned of a reef on the west side of the main channel, off Bayonne. The Lighthouse Service annual report for 1883 said that the "old stone tower was torn down, and a four-section iron tower erected in its place," with a fourth-order lens 56 feet above the water. (Coast Guard.)

Romer Shoals, shown under construction in 1898, was built of standardized iron plates. With these plates, lighthouse construction was faster and cheaper than it was with brick or stone. Iron is strong, watertight, and slow to deteriorate in salt water. The Lighthouse Service began using iron plates in the late 1840s. One of the first lighthouses made of cast iron was the old Brandywine Shoal Lighthouse in Delaware Bay, erected in 1848. Romer Shoals was placed on a caisson base, another measure that saved time and money in comparison with other types of foundations. Caissons were widely used in northern waters.

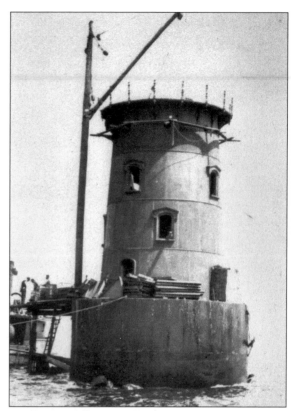

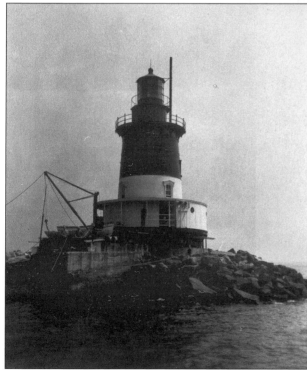

Romer Shoals, shown c. 1940, replaced an 1838 daymark warning of a shoal 2 miles from Sandy Hook. The shoal was named after the ship *William J. Romer*, which sank here in 1863. The lighthouse was painted red and white and had a fourth-order Fresnel lens 54 feet above water. The light was put into service in 1898. (National Archives.)

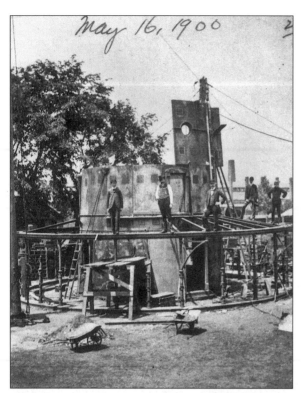

May 16, 1900

West Bank Lighthouse was under construction at the West Side Foundry Company in Troy, New York on May 16, 1900. The use of iron plates and a caisson foundation was substantially cheaper and faster than other construction methods. There were several types of caisson construction. In its simplest form, the cylindrical caisson is built at a foundry and towed to the lighthouse site. It is then filled with concrete. The caisson rests securely on the bottom, and the lighthouse building—which for the most part has already been completed onshore—is secured atop the caisson. (National Archives.)

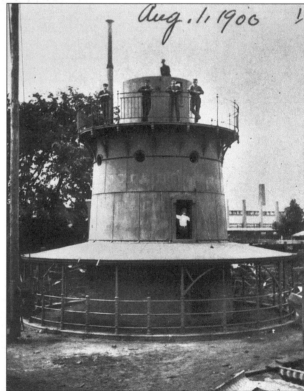

Aug. 1, 1900

Some 50 caisson lighthouses were built in northern waters in depths of up to 30 feet because screw-pile structures, popular in southern waters, could not stand up to ice floes and rapid currents. West Bank was built using the pneumatic caisson process. (National Archives.)

West Bank Lighthouse, shown in 1951, was the tallest of the harbor lights at 69 feet and was put into service in 1901. The lighthouse features a fourth-order lens showing a white light with a red sector marking the junction of Ambrose Channel. It formed a range with the Staten Island Lighthouse in Richmond. It stands in 21 feet of water off the south end of the bank, on the west side of the Main Channel. (Coast Guard.)

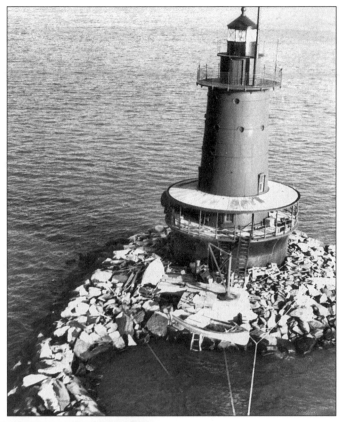

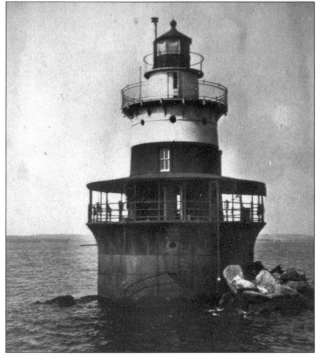

Old Orchard Shoal, shown c. 1900, is another caisson lighthouse. It stands in an area of New York Harbor once called Princess Bay, off the southern edge of Staten Island. In 1890, the annual report of the Lighthouse Board stated that a light was needed here because the "tonnage passing through Princess Bay has materially increased since the erection of the railroad bridge across Staten Island Sound. The channel is quite narrow." On March 31, 1891, Congress appropriated $40,000 for a light and fog signal. (Coast Guard.)

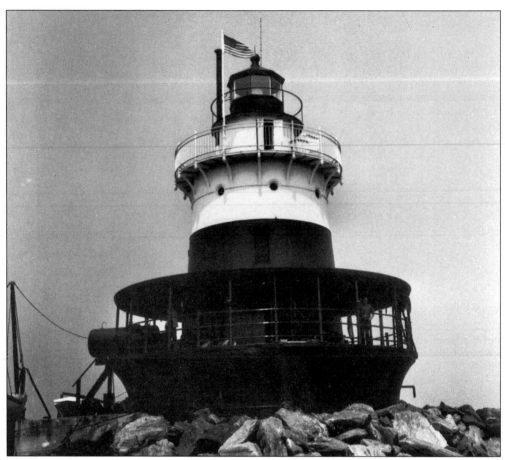

Old Orchard Shoal, seen here in 1951, was completed and lighted in April 1893. The light warns of the shoal and also serves as a range with Waackaack Light. Standing in 17 feet of water on the east side of the shoal near Gedney Channel, the light has a fourth-order lens 51 feet above the water. (Coast Guard.)

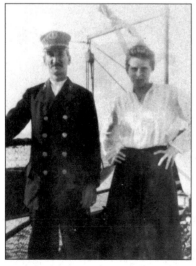

Great Beds keeper E.J. Smith and his wife pose in December 1916. Although many people refer to the person in charge of a lighthouse as captain, the official title was keeper. Today, the only light in the country that still has a keeper is Boston Harbor Light; all the rest are automated. (National Archives.)

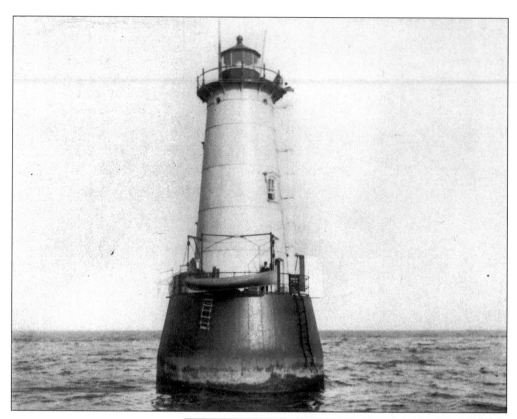

Great Beds Light warns of a shoal at the junction of the channels of the Raritan River and Kill van Kull. In 1868, local shipowners and businessmen petitioned the Lighthouse Board for a lighthouse in Raritan Bay, off Perth Amboy. After a delay of almost a decade, Congress appropriated $34,000 for the lighthouse on June 20, 1878. The light stands in 5 feet of water and was lighted on November 15, 1889. Painted various colors over the years, the lighthouse is now white. (National Archives.)

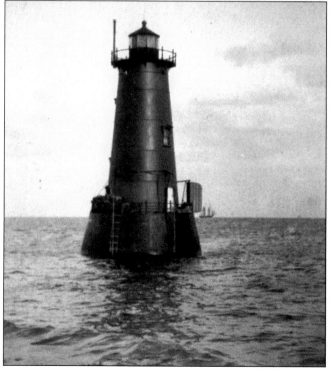

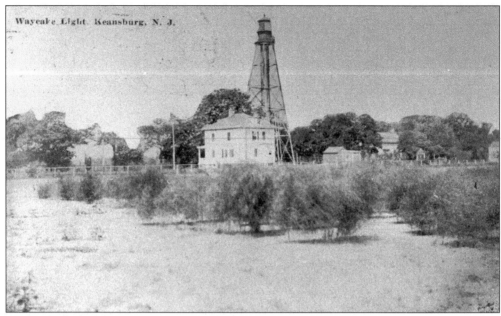

Waackaack Light (*c.* 1900) in Keansburg was part of a series of range lights near Sandy Hook that served Swash, Gedney, Sandy Hook Channels, and later Ambrose Channel, leading into New York Harbor. A range, generally two lights, features a front light that is lower than the rear right. This arrangement helps skippers find the centerline of the channel by lining up the rear light above the front light. Waackaack, pronounced "way-cake," was also known as Point Comfort Light. (T.J. MacMahon.)

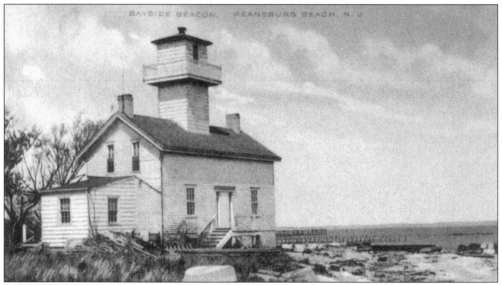

Point Comfort Lighthouse, also known as the Waackaack front range or Bayside Beacon, was built in 1856 in Keansburg. Seen here *c.* 1900, the lighthouse was replaced by a steel tower, later called the Bayside Beacon. It was one of six lighthouses in the series of ranges for New York Harbor. Four were located in New Jersey and the other two on Staten Island. All the lighthouses were built by Richard Calrow Jr. of New York City at a total cost of $19,124. (T.J. MacMahon.)

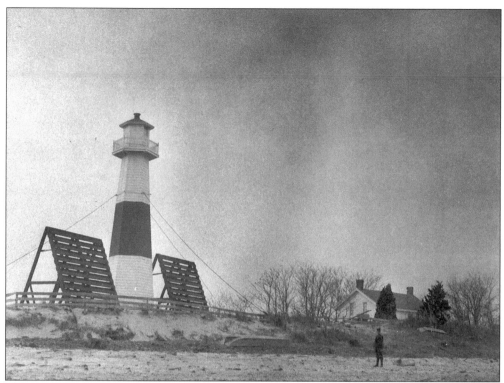

Conover Beacon, seen here in 1933, was one of the lights built by Richard Calrow Jr. The lights were described as "three hexagonal towers, three keepers' dwellings with light turret in the center, and three separate keepers' dwellings, all of wood, upon foundations of brick laid in cement." At some point in the 1930s, this light was replaced by a steel tower, which was once the Bayside Beacon. The light was in Leonardo. (Coast Guard.)

The new Conover Beacon, seen in this 1941 photograph, still stands on a beach in Leonardo, property that was deeded to the government on July 30, 1853. It overlooks Sandy Hook Bay and serves, along with Chapel Hill Lighthouse, as a range for the Main Channel into New York Harbor. The tower is the former Bayside Beacon, which was moved to its current position sometime in the late 1930s. (Coast Guard).

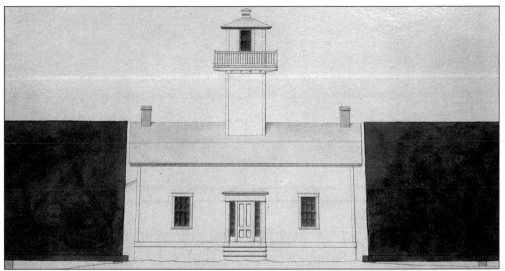

Chapel Hill Lighthouse is shown here in an architectural rendering done in 1874, when new daymarks (patterns and colors) were added to the structure. Chapel Hill is another one of the six lights built by Richard Calrow Jr. It is located on a hill about a mile and a half from Conover Beacon, which is on a beach in Leonardo. Chapel Hill derives its name from the small church that was once nearby. Range lights were originally named for the place they were located, but eventually they came to be called by the waterways through which they guided ships. (National Archives.)

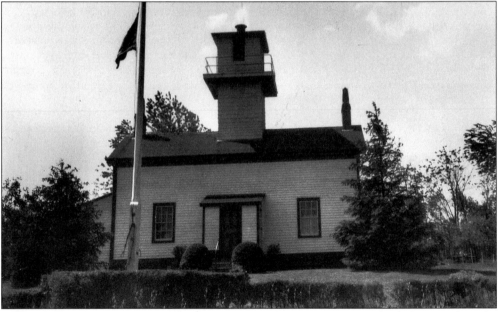

Chapel Hill Lighthouse, pictured here c. 1941, was lighted in 1856. The light served as the rear range for Conover Beacon, guiding ships through the Main Channel, or Sandy Hook Channel. The light was displayed from a tower extending 40 feet above the roof and, according to the the Light List, was 122 feet above sea level. The light was moved to a tower in the mid-1950s, and the lighthouse was decommissioned. The building is now a private residence. (National Archives.)

Three

COASTAL LIGHTS

The most obvious 19th-century attempts at preventing shipwrecks are the stately lighthouses that grace New Jersey's coast. As romantic and appealing as they are, in Coast Guard terms these beacons are simply light stations and aids to navigation. Atlantic seacoast lighthouses were tall and painted in bold colors or patterns, not for aesthetic reasons but to lift the light high enough above the flat, sandy coastal plain so that it was visible some 15 miles out to sea. Patterns and colors known as daymarks differentiated one lighthouse from another so that mariners knew where they were. The height of a lighthouse affects how far it can be seen. The Lighthouse Service, in its Light List, included a table showing a light's range. For instance, a light on a 50-foot tower was visible for 8 miles and one on a 150-foot tower was visible for 14 miles or more, depending on the height of the viewer above sea level.

New Jersey has four seacoast (primary) lights. Three are towering buildings, all over 155 feet high: Cape May, Absecon, and Barnegat. The fourth is Twin Lights with towers that, although substantially shorter than 155 feet, sit on a bluff that puts them at 246 feet above sea level, making them the tallest lights along the Atlantic coast between Florida and central Maine.

Other smaller lighthouses along the coast, such as the Victorian-style lighthouses at Sea Girt and Hereford Inlet, served mainly to mark approaches to harbors and were not primarily for offshore navigation.

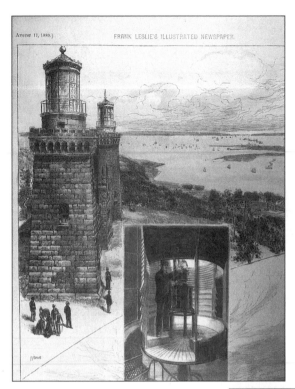

"New Twin Lights most picturesque lighthouse structure on the Atlantic Coast," said *Frank Leslie's Illustrated Newspaper* as a caption for this drawing, appearing on August 17, 1889. The original Twin Lights was built in 1828. The current structure dates from 1862 and was built at a cost of $74,000. It is the only lighthouse in the United States built in a fortress style. It was designed by architect Joseph Lederle of Staten Island and was constructed of brownstone, an unusual feature as brownstone was mainly a residential building material. (Twin Lights Historical Society.)

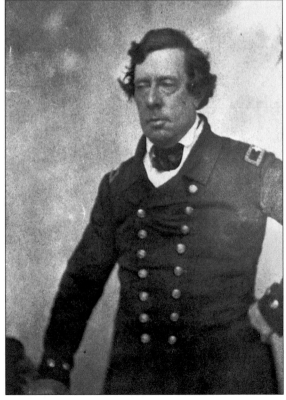

In 1841, Capt. Matthew C. Perry—later renowned as a commodore for ending Japan's two centuries of isolation—bought the first Fresnel lens in Paris for a U.S. lighthouse and had it installed in the south tower of Twin Lights. Perry, shown in this rare 1845 daguerreotype, had other ties to New Jersey. In an 1837 report, he stated that New York Harbor pilots charged double to go to New Jersey ports because of the lack of aids to navigation, and those double charges made ships want to avoid ports here. (National Portrait Gallery.)

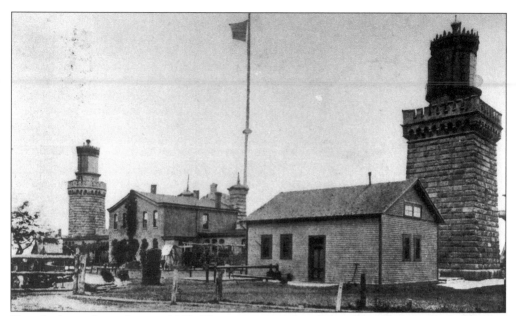

Twin Lights is shown here in 1903. This structure replaced the earlier Twin Lights because, as the 1852 Report said, the towers "are in a dilapidated condition, the consequence of original bad materials and workmanship, and it has been represented that there is apprehension they are not capable of standing much longer." The first light keeper was Joseph Doty of Somerville, who was paid $40 a month in 1828. (Twin Lights Historical Society.)

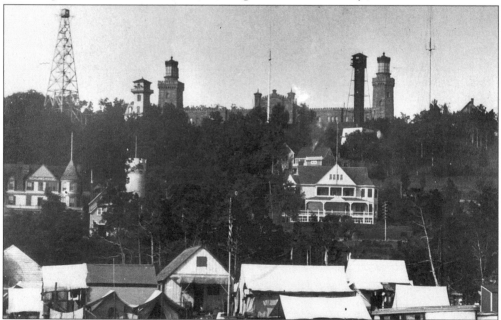

This c. 1940 photograph of Twin Lights shows its radar masts. In the 1930s, engineers and scientists from nearby Fort Monmouth conducted secret radar experiments here. Radio on a commercial basis was first used here on September 30, 1899, with Guglielmo Marconi on the steamship *Ponce* reporting on the progress of a naval review for Commo. George Dewey, victor at Manila Bay in the Spanish-American War. (Twin Lights Historical Society.)

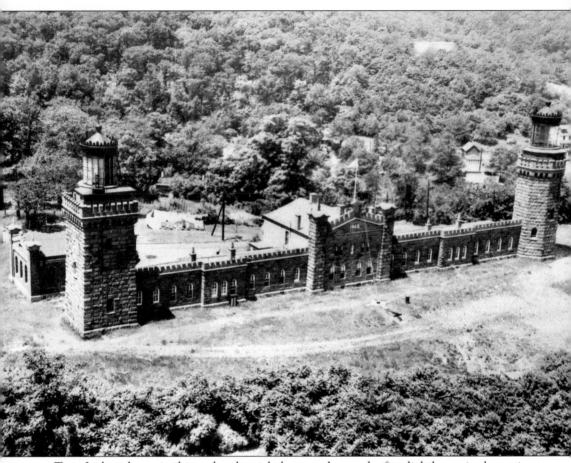

Twin Lights, shown in this undated aerial photograph, was the first lighthouse in the nation to use kerosene (then called mineral oil) instead of lard to light the beacon in the north tower. In 1898, a new lens in the south tower was the first regular U.S. lighthouse powered by electricity, which was produced from a separate generator building behind the lighthouse. In 1917, radio beacons for navigation were tested here. The towers are 250 feet apart and are connected by the keepers' dwellings. The light ceased operating in October 1954, and the facility was turned over to the Borough of Highlands. It was a victim (for the usual reasons) of efficiency and economy, as other aids to navigation replaced it. It is now a state park with a small museum. (Coast Guard.)

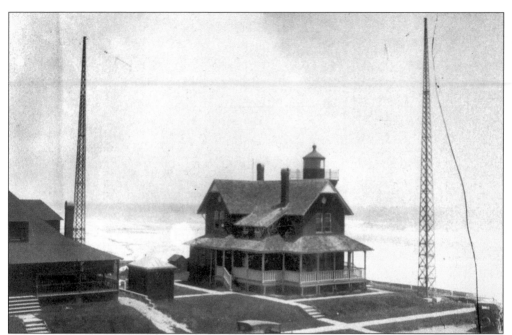

Sea Girt is seen here *c.* 1930. The deed for the property of this Victorian-style lighthouse dates from July 29, 1895, although funds were first allocated in 1889. In all, problems with site and deed delayed lighthouse construction until 1896. The light was exhibited for the first time on the night of December 10, 1896. While Lighthouse Service annual reports are full of tales of woe about the sea encroaching on their properties, the 1904 annual report noted that, for Sea Girt, "a fence was put up to keep sand from drifting onto the lawn." (Coast Guard.)

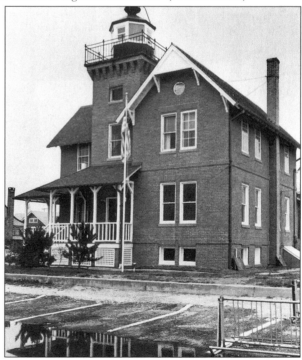

This photograph of Sea Girt is undated but is probably from the 1960s. It is often said that the lighthouse must have been moved, because it doesn't appear to be guarding anything; however, the inlet it protected was closed long ago. The light also served as land-based continuity between the seacoast lights at Barnegat and Navesink. It had a fourth-order lens. In 1921, Sea Girt, along with *Ambrose Lightship* and *Fire Island Lightship*, were the first facilities to have radio beacons for navigation and fog warnings installed. (Coast Guard.)

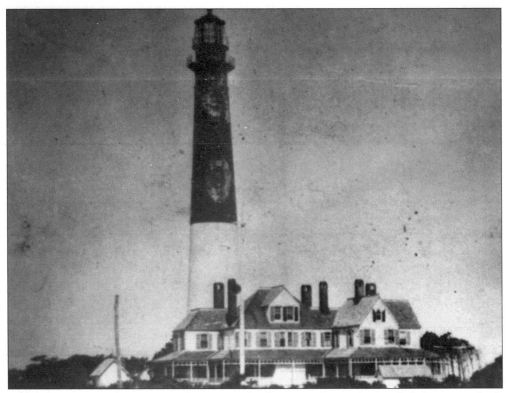

Barnegat Light, *c.* 1925, had a triple keepers' dwelling at its base. The first lighthouse was built at this site in 1835; it was 40 feet high. On October 25, 1834, the site was bought from Bornt Slight and his wife, Ruth, of Tuckerton for $300. On August 3, 1835, Henry V. Low appointed the first keeper, who served until his death on March 12, 1838. The inadequate early light was a constant source of complaint. The 1852 Report quoted Capt. H. K. Davenport, U.S. Navy, commanding the mail steamer *Cherokee*: "It is frequently mistaken for a vessel's light; in hazy weather cannot be seen more than seven miles. Vessels bound to New York from the south generally run for this light, and it is of great importance that it should be a first order light." (Ocean County Historical Society.)

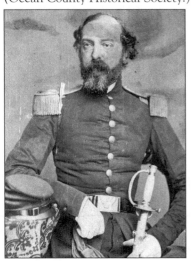

George Gordon Meade, as a general in charge of Union forces at the Battle of Gettysburg, surveyed Barnegat Light in 1855. Shown here as a captain, Meade first worked on New Jersey's lighthouses in Delaware Bay while serving as a lieutenant in the army's Bureau of Topographical Engineers. Later, he was an engineer in charge of the Fourth Lighthouse District, where he worked at Barnegat and Absecon Lights. In late 1856, he was promoted to captain and placed in charge of the Great Lakes Survey. The Bureau of Topographical Engineers was a separate all-officer unit that split from the Army Corps of Engineers in 1837 to perform mainly civilian works. The group rejoined the Army Corps in 1863. (U.S. Army Military History Institute.)

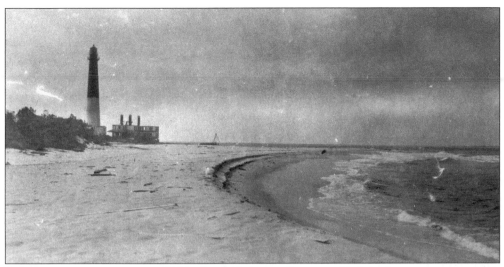

Following a severe storm in 1921, the Lighthouse Service added further jetties to protect Barnegat Light, which had replaced the old lighthouse in 1859. On August 18, 1856, Congress authorized $45,000 for rebuilding the light. James Fuller of Vermont, the last keeper of the old light, transferred to the new light on January 6, 1859, when it was first displayed. The lighthouse is 161 feet tall. The 1892 Light List described it as "on the south side of Barnegat Inlet on the north end of Long Beach, a first order light, flashing white every 10 seconds, the lower half of tower white; upper half red; lantern black; Dwelling white with lead-colored trimmings and green shutters." (National Archives.)

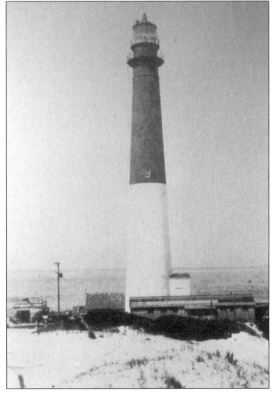

This photograph shows Barnegat Light in 1927. F.R. Eldridge, a Coast Guard historian in the 1950s, described its role: "The lighthouse on Barnegat shoals was a very important light in its day. With Fire Island on the other side, it marked the true mouth of New York Harbor. Vessels bound to New York from Europe or from the South often made land in the vicinity of Barnegat shoals." (Ocean County Historical Society.)

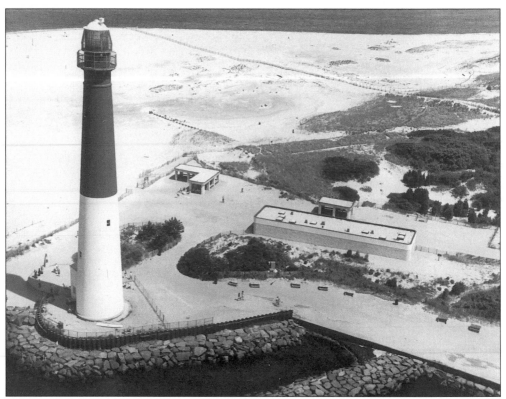

Barnegat Light, shown in this undated aerial photograph, was in constant battle against the sea. The old lighthouse was swept away by the ocean in 1857. The new light was built about 900 feet back from the one it replaced. By 1869, nine jetties had been built and 1,220 tons of stones had been dumped on the beach. On May 8, 1926, the Barnegat Light property was transferred to the state, although the Coast Guard had the light until January 1, 1944. The *Barnegat Lightship* offshore made the light unnecessary. (Coast Guard.)

This Tucker's Beach Lighthouse photograph was taken from one-half mile offshore in 1897. Called locally by various names, it was officially known as Tucker's Beach Lighthouse and was located on what was once the southern extension of Long Beach Island. The lighthouse was built in 1848 and was 50 feet above the water. The fourth-order lens was made by Henry Lepaute of Paris. The keeper's dwelling—one-story tall, with a finished attic—was constructed of brick. The 1897 annual report mentions for the first time the problem of flooding tides, which eventually drowned the island. (National Archives.)

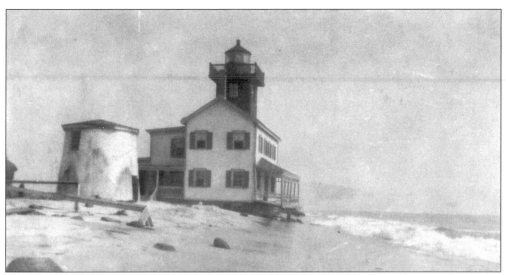

In this September 1927 photograph, Tucker's Beach Light appears as it did shortly before the station was swept into the sea. In 1859, the station was discontinued; it was reestablished in 1867. The 1855 Lighthouse Service annual report states: "When the first class light is lit at Absecum, the Tucker's Beach light will be unnecessary and inconvenient for purposes of general navigation. Indeed it will be of small local importance, as vessels cannot safely enter Little Egg Harbor at night. It will be quite sufficient to reduce it to a small harbor light, perhaps distinguished by a red or green color." (National Archives.)

The Life-Saving Service building can be seen in the foreground of this photograph of Absecon Light *c.* 1880. Dr. Jonathan Pitney, the founder of Atlantic City in the mid-1830s, lobbied for 20 years to get a lighthouse. Pitney argued that the *Powhattan* shipwreck of 1854 could have been averted had there been a lighthouse at Absecon Island (the ship stranded 2 miles above Little Egg Harbor). Construction of the light began under the direction of Gen. Hartman Bache, continued under George G. Meade, and was finished by Lt. Col. William F. Reynolds (spelled "Raynolds" on some architectural plans). (Atlantic City Free Public Library.)

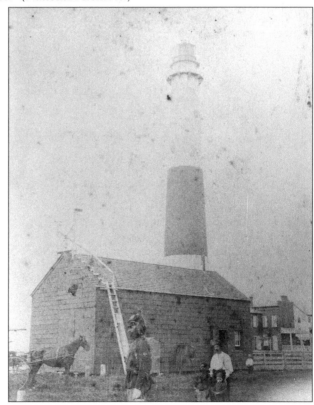

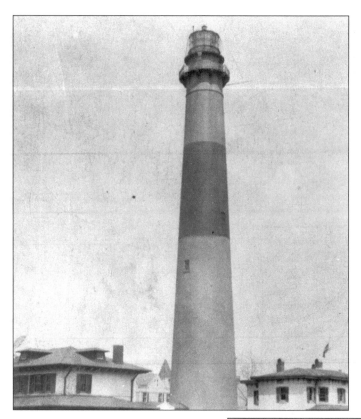

On January 15, 1857, the Funck mineral oil lamp was lighted at Absecon Lighthouse for the first time. The light had a first-order Fresnel lens and cost $52,187. It measured 171 feet tall and 27 feet in diameter at its base. The first keeper was Daniel L. Scull, who was appointed on Nov 25, 1856 and paid $600 annually. (Coast Guard.)

The color of Absecon Lighthouse has varied over the years. Originally, it was unpainted brick but in August 1871, it was painted white with a large red band in the center. In August 1897, it was repainted orange with a center black band, and from 1925 to 1933 it was yellow with a black band. Sometime in 1933, it was painted white with a blue center band. Today, it is buff-yellow with a black band. (Atlantic City Free Public Library.)

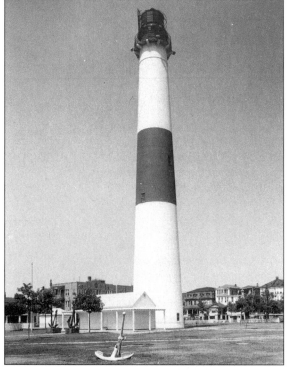

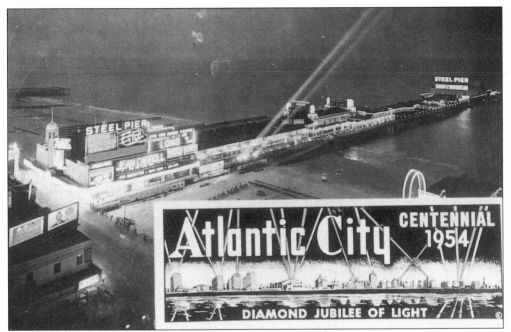

City buildings began to obstruct Absecon Light, and it ceased operating in June 1933. It was replaced by a navigation beacon at the end of Steel Pier, shown here in 1954. Atlantic City, although founded in the mid-1830s, was not incorporated as a municipality until 1854. (Atlantic City Free Public Library.)

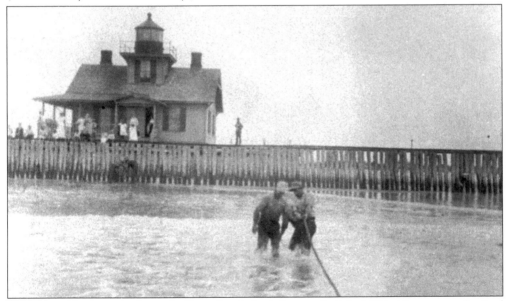

This 1914 photograph shows Ludlum Beach Lighthouse. In July 1884, Congress authorized $5,000 for the light. The lighthouse was described in annual reports as a white frame building with green shutters, serving as both the keeper's dwelling and the lighthouse on top. The light was to guard Townsend Inlet and to warn mariners of bars off Sea Isle City. On November 3, 1885, the light, with its fourth-order lens, was activated for the first time, under keeper Joshua Reeves. (Coast Guard.)

Lighthouse Service annual reports are filled with remarks about the continuing battle of protecting Ludlum Beach Lighthouse against encroaching seas. Not the ocean, however, but a November 1923 fire finally destroyed the light, pictured here in 1921. The lighthouse was replaced by a steel pole light, located at what is now Thirty-first Street and the beach. The pole light operated until 1962. The old lighthouse still exists in an altered state as a private residence located on the corner of Thirty-fifth and Landis Streets. (Coast Guard).

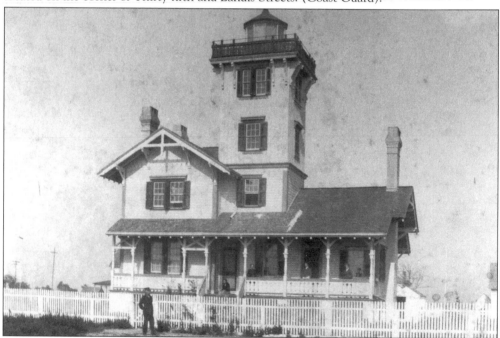

Keeper Freeling Hewitt stands by a fence near Hereford Inlet Lighthouse in 1903. The lighthouse was built under direction of Lt. Col. William F. Reynolds, Army Corps of Engineers, in 1873. The annual report for that year said, "It is built in accordance with Class C, fourth order, Harbor Lighthouse and Keepers Dwelling, as issued by the Lighthouse Board." The fourth-order light was first displayed in 1874 and is 47 feet above the base of the house. (Cape May Historical and Genealogical Society.)

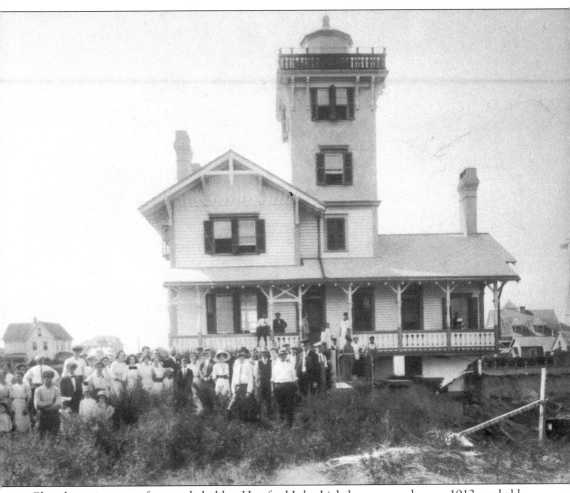

Church services were frequently held at Hereford Inlet Lighthouse, seen here *c.* 1912, probably after a service. Congress approved $25,000 on June 10, 1872, to build a lighthouse because "A small light, say a fourth order, is respectfully recommended for this place, as it would be of importance to the coal trade and to steamers navigating Delaware Bay and River, and to mark the entrance to the inlet, where there is a good harbor of refuge for small coasting vessels." It was built in what is called Swiss Gothic style at the end of Five-Mile Beach, near the life-saving station by Hereford Inlet. It is open to the public. (Hereford Inlet Lighthouse Association.)

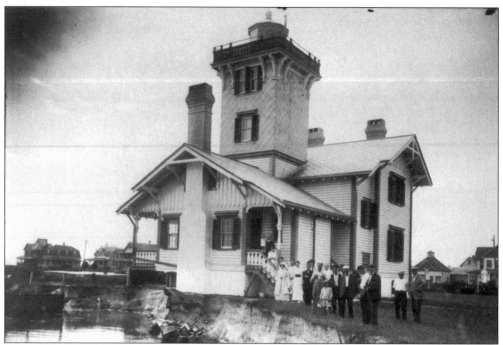

The storm damage apparent in this August 1913 photograph of Hereford Inlet forced the lighthouse to be moved away from the ocean. The sea also claimed one of its early keepers. The 1875 annual report notes that "On August 9, 1874, John March, the keeper of the station, was drowned by the capsizing of his boat, on returning from the mainland to the station." The lighthouse ceased operating in the early 1960s, replaced by a steel skeleton tower. The light was returned to the newly refurbished lighthouse in 1986 and still operates. (National Archives.)

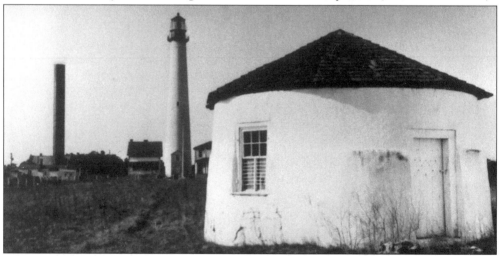

In the foreground of this undated picture is the base and about 10 feet of the second Cape May lighthouse, built in 1847. The third and present light can be seen in the background. It is difficult to believe that there was not a lighthouse at Cape May (marking the northern entry to Delaware Bay) before 1823, the date the first lighthouse is documented. There was a light marking the southern entry to Delaware Bay at Cape Henlopen, Delaware, in 1767. The 1823 lighthouse eventually succumbed to waves. (Mid-Atlantic Center for the Arts.)

This undated photo features a good view of the lantern at Cape May Lighthouse. The 1859 lighthouse was built only a dozen years after the second lighthouse was completed. The second was condemned in the 1852 Report because of its shoddy construction. The earlier lighthouse was built on 2 acres, purchased on April 9, 1847, from Alexander Whilden for $1,150. It was torn down in 1862 to avoid confusing mariners. (Mid-Atlantic Center for the Arts.)

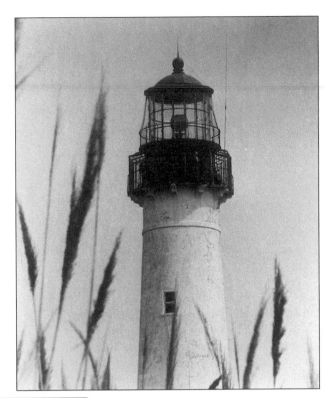

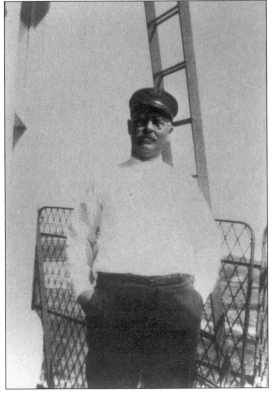

Harry Hill Palmer, pictured *c*. 1930, was the last keeper at Cape May. He was paid $960 annually in the 1920s. The light was automated in 1938. A year later, when the Lighthouse Service was merged into the Coast Guard, lighthouse keepers were given the option of becoming Coast Guard officers or remaining as civilian employees. About half chose each option. By the early 1960s, most of the civilian lighthouse keepers were retired. (Mid-Atlantic Center for the Arts.)

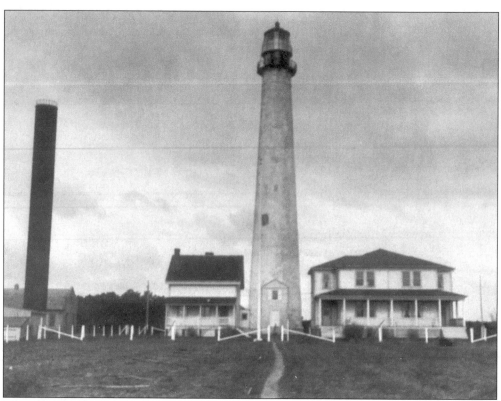

This photograph of Cape May Lighthouse and its keepers' dwellings in 1933 shows a black "smokestack" in the background, which is a water tower no longer in existence. Cape May Light—a brick structure with long, spiraling iron stairs—is the perfect example of a lighthouse that inspired innumerable ghost stories. According to one knowledgeable engineer, ghost stores are associated with lighthouses because the structures are made of different materials, such as iron staircases and platforms inside brick or stone structures. These materials expand and contract with the heat and cold at different rates, making creaking and groaning noises that create enough strange sounds to startle the fainthearted or lead the gullible to search for supernatural explanations. (National Archives.)

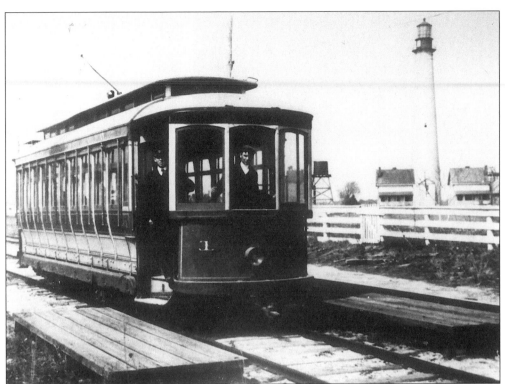

The Cape May trolley ran from the center of town to Cape May Point. The current lighthouse, still in use, is 157 feet tall and initially had a first-order Fresnel lens. It was put into service in October 1859. It marked the northern entrance to Delaware Bay and also warned of shoals southward. Cape May looks very much like Barnegat and Absecon Lights. On occasion, the same basic architectural plans were used for more than one lighthouse, and this could be the case with New Jersey's three seacoast lights. In the photograph at the right, a child who probably belongs to the lighthouse keeper stands in front of the light near the water tower. (Cape May Historical and Genealogical Society.)

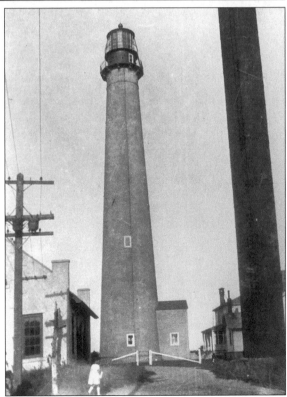

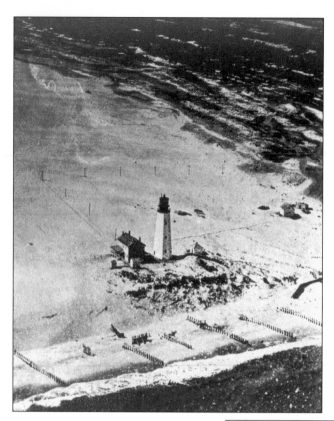

Cape Henlopen Lighthouse, Delaware, shown *c.* 1922, was one of the original Colonial lights. It was an eight-sided structure, funded by a lottery sponsored by Philadelphia businessmen and shipowners. The light marked the southern entry to Delaware Bay and was in operation by 1767. Its lantern was 82 feet above the ground. During the Revolutionary War, the interior of the tower was gutted by fire, perhaps set by British soldiers because it served as a lookout tower for American forces. It was relighted in 1784 and had a first-order Fresnel lens installed in 1855. (National Archives.)

This photograph shows Cape Henlopen Lighthouse as it looked in April 1925. Passengers on the Cape May–Lewes Ferry or visitors to Cape Henlopen State Park in Delaware search in vain for the lighthouse that they know must be there. Indeed, it used to be there, but it toppled into the sea in the spring of 1926. For much of its existence, the lighthouse was assaulted on two fronts by the sea on on land by a large moving sand hill, which still exists. The encroaching sea finally won: it scoured sand away from the base until the lighthouse finally fell. (National Archives.)

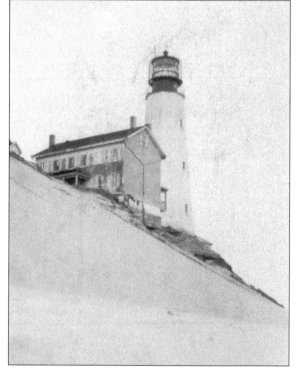

Four

THE DELAWARE BAY AND RIVER LIGHTS

Before William Penn decided to center his colony in Philadelphia, he had soundings of the Delaware River taken to ensure that oceangoing ships could reach the city he had planned. The 50 or so miles from the junction of the bay and river is a twisting course to Philadelphia, with shoals and mud flats posing hazards to navigation.

In 1850, *Blunt's American Pilot*, a book of sailing directions and hazard warnings (first published in 1804 or earlier) described entering Delaware Bay: "South-west from Cape May Light, half a mile distant, there is a shoal of one-fourth a mile in extent. South point of Crow Shoal bears West 22 degrees from the Cape May Light, the shoal is four miles in extent, in a north direction, having on it only seven feet in places."

As the bay narrows into the river, north of Ship John Shoal, a series of range lights—the most in the United States—guides vessels through the turns of the Delaware River to Philadelphia. Range lights were on both sides of the river; only the New Jersey range lights are covered (see page 26 for an explanation of range lights). Of the seven range lighthouses, only two remain: Finns Point Rear Range and Tinicum Rear Range. The lighthouses that still operate in the bay, all inaccessible except by boat and closed to the public, are as follows: Brandywine Shoal, Fourteen-Foot Bank (in Delaware waters), Miah Maull Shoal, Elbow of Cross Ledge, and Ship John Shoal.

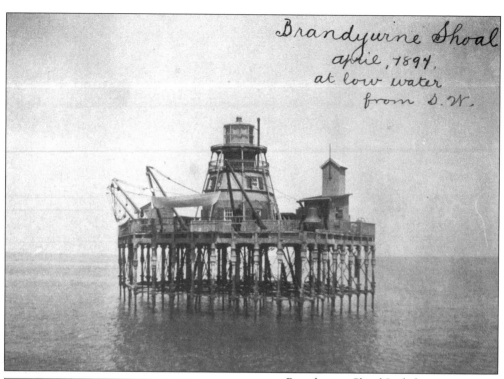

Brandywine Shoal
April, 1894,
at low water
from S.W.

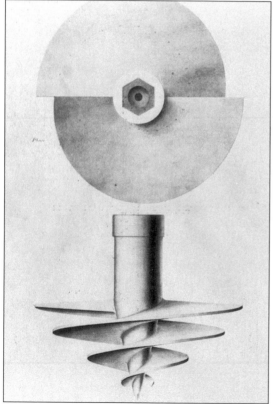

Brandywine Shoal Lighthouse, seen in the above photograph in April 1894, was established in 1823 by light vessel. A lighthouse was built in 1827, but it was soon destroyed by ice floes. A light vessel reoccupied the station until October 1850, when the nation's first screw-pile lighthouse was finished. Screw-pile lighthouses, invented in England, featured a large corkscrewlike flange on the end of each of the nine pilings used to anchor the structures, which were literally screwed into the subsurface. The superstructure was then mounted on a foundation on top of the pilings. In later years, iron pilings and braces were added to Brandywine Shoal Lighthouse as protection against ice floes. Although the first screw-pile lighthouse was built in Delaware Bay, this type of construction became popular in the Chesapeake Bay and other southern waters, because ice and fast-moving currents created problems for them in northern waters. The photograph on the left shows a screw-pile blade. (National Archives, above; Coast Guard, left.)

The light structure at old Brandywine Shoal Lighthouse, seen here in 1914, was made of cast iron—one of the first lighthouses in this country to use this material. It was built by Maj. Hartman Bache of the Army Topographical Engineers, assisted by George G. Meade. With its fourth-order lens, the light was first exhibited on October 31, 1850. There was a head keeper and three assistant keepers, typical staffing for bay lights. In 1852, it was one of only three U.S. lighthouses with a Fresnel lens. (National Archives.)

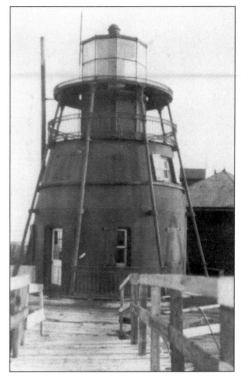

This is how the fog horn at old Brandywine Shoal looked in 1914. Light stations in many cases also had foghorns and later, radio navigation equipment, making them more than just towers displaying lights. (National Archives.)

New Brandywine Shoal was under construction in October 1914. The old lighthouse's underwater pilings were examined by the Army Corps of Engineers in 1873. The issued report said, "This structure having stood for 25 years, and being one of the earliest examples of iron-pile lighthouses, and subject since its construction to an annual assault by great fields of ice that the action on the iron has been quite irregular, some of the piles not having worn perceptibly, while other have diminished in diameter quite half an inch." However, it was almost another 40 years until the lighthouse was replaced with a more spacious, modern facility. (National Archives.)

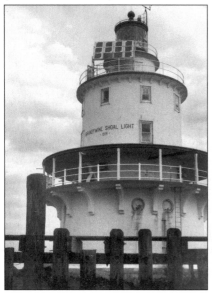

This view shows Brandywine Shoal as it looks today. The lighthouse was put into service on October 20, 1914, with a third-order Fresnel lens. It rose 60 feet above the water. The three-story dwelling and light is cylindrical concrete attached to a circular concrete pier. The concrete pier was made on shore, towed to the site, and then sunk into position on top of a wooden foundation. It is painted white with red trim. Rock jetties, or riprap, provide a small harbor for vessels servicing the lighthouse. (Author's photograph.)

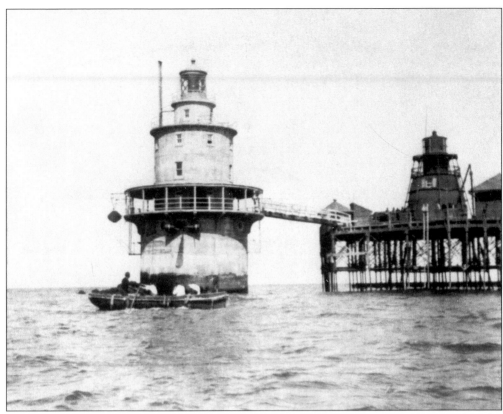

Both the old and the new Brandywine Shoal Lighthouses appear in these two photographs. The above view dates from 1914. (National Archives.)

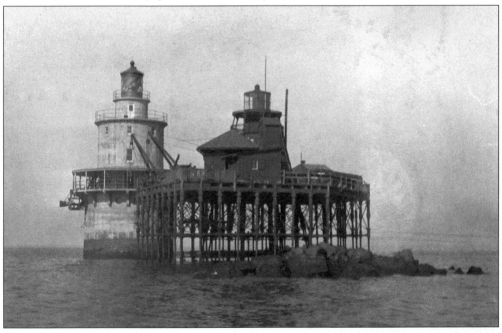

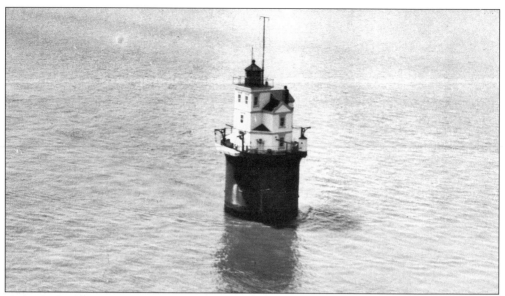

Fourteen-Foot Bank, pictured here *c.* 1950, is about 3.5 miles from the Delaware shore and 14.5 miles northwest of Cape May Light. The lighthouse marks a ship turning-point and the Joe Flogger Shoal, which is almost 15 miles long and forms the western side of the main shipping channel. The Lighthouse Service describes the structure as "a two story cast-iron building with a tower," but it really looks like a Victorian home sitting on top a large cylinder. It went into service in April 1887, and its light is 59 feet above the bay. (National Archives.)

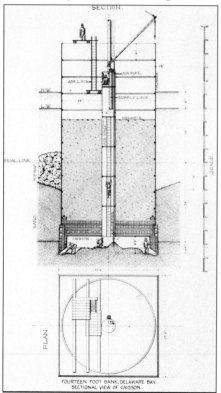

This engineering drawing of the Fourteen-Foot Bank pneumatic caisson illustrates the process of using air pressure to keep water out of the caisson as work crews dug their way through uneven underwater terrain. A Lighthouse Service description of the process said, "a working party in the caisson consisted of three gangs of eight men each, who worked for eight hours, with a rest for meals after four hours. They were paid $2 for seven and a half hours work in the caisson." This method was based on a German system. (National Archives.)

52

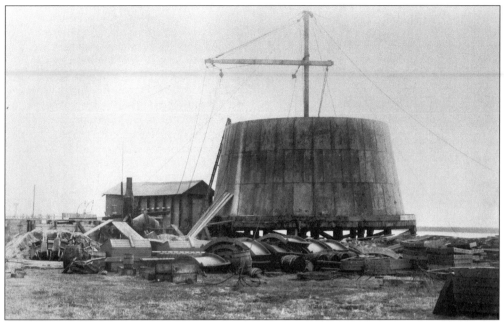

This photograph shows the partial foundation of Miah Maull Shoal Lighthouse as it looked in 1908. The shoal is believed to be named after a Lewes, Delaware ship captain, Nemiah Maull, whose ship sank on the shoal in the 1780s. Maull probably drowned there. The dangerous shoal is east of the main shipping channel at the widest part of the bay, midway between Fourteen-Foot Bank and Elbow of Cross Ledge Lights. (National Archives.)

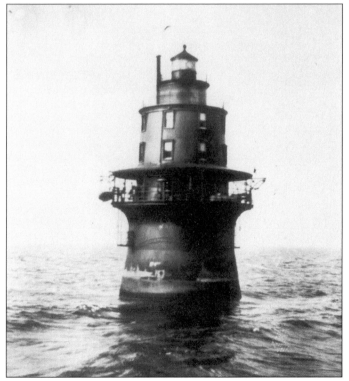

The structure of Miah Maull Lighthouse in 1912 consisted of a cast-iron pier filled with concrete, curving out into a trumpet-shaped deck top, which is 26 feet above the water. A three-story, circular house made of iron is on top of the pier. The lighthouse was completed on June 15, 1915, at a cost of $104,102.48. A fourth-order light is exhibited from the top of the house. (National Archives.)

53

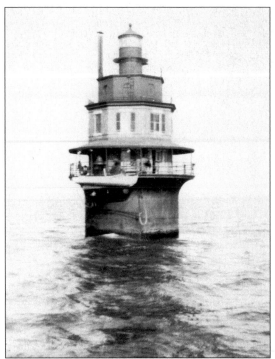

Elbow of Cross Ledge, *c.* 1910, was an attractive eight-sided brick-and-iron building on top of a pneumatic caisson. The first two stories are brick, topped off by an iron deck and iron watch room, where the fourth-order lens was first displayed on February 1, 1910. The lighthouse was built because Cross Ledge Lighthouse apparently was poorly situated and was too far inside the Cross Ledge Shoal to be of value. Earlier, *Upper Middle Lightship* had warned of the shoal. (National Archives.)

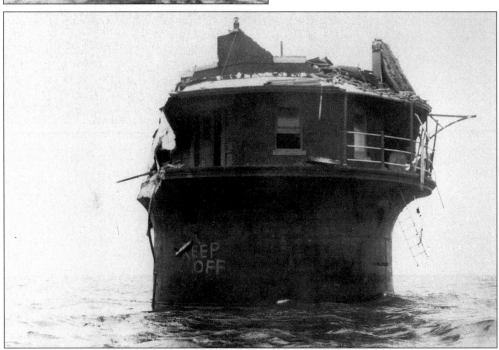

This photograph shows the Elbow of Cross Ledge Light on October 23, 1953, three days after it was rammed in heavy fog by the ore-carrying freighter U.S. *Steel Apprentice*, which was bound for Philadelphia. The ship received a gash but was able to proceed under its own power; however, the freighter hit with such force that it demolished the lighthouse's living quarters. The lighthouse had been vacant since its automation in 1951. (Coast Guard.)

The photograph at the right shows the economic and efficient solution for replacing the damaged Elbow of Cross Ledge Light: a steel skeleton tower on top of the original caisson base. Although this is a 1955 view, the structure looks the same today. The photograph below, taken in 1975, shows all that remains of Cross Ledge Lighthouse. The light stood abandoned from 1910 until 1962, when it was razed by the Coast Guard. (Coast Guard.)

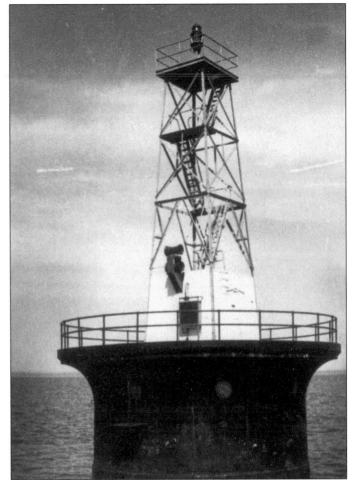

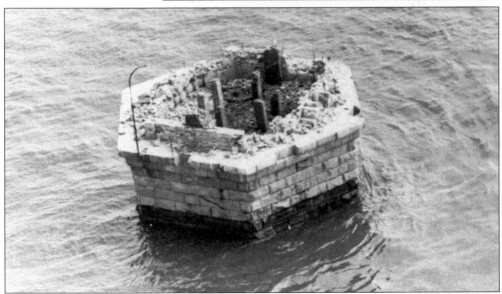

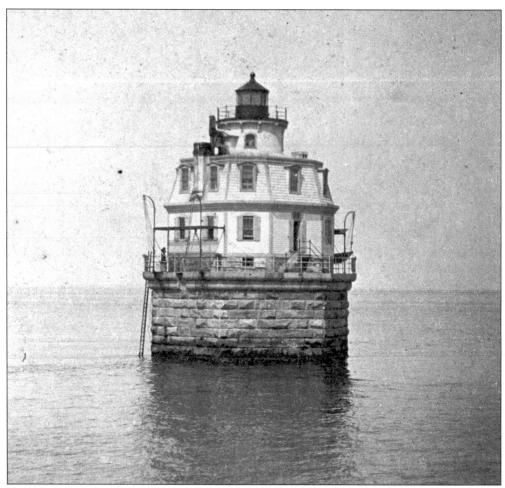

Cross Ledge Lighthouse, pictured in 1885, was first established in 1823. At that time *Upper Middle Lightship* marked the hazardous Upper Middle, or Cross Ledge, Shoal near the middle of Delaware Bay, about 5.5 miles from Egg Island Light on the Cumberland County shore. Because the lightship was frequently driven off station by ice and lighthouses were cheaper to maintain, it was eventually replaced by the lighthouse. In 1856, an attempt was made to build a screw-pile lighthouse, but heavy ice destroyed the partially completed structure. The three-story, wood-frame house with mansard roof, perched on a granite pier, was finished in 1878. It had a fourth-order lens mounted in a lantern atop the house, which was 58 feet above the bay. In February 1910, the light ceased operating because Elbow of Cross Ledge and Miah Maull Lighthouse provided adequate warning for the shoal. (National Archives.)

Towing the Caisson into position.

This drawing by an unidentified artist depicts the caisson for Ship John Shoal Lighthouse being towed into position in 1874. The hazard is named after the ship *John*, a Boston-based ship that was on its way from Hamburg, Germany, to Philadelphia when it struck the shoal and sunk in December 1797. The cast-iron cylindrical caisson is filled with concrete, forcing it to rest on 97 wooden piles, cut to a level 16 feet below the water's surface. (National Archives.)

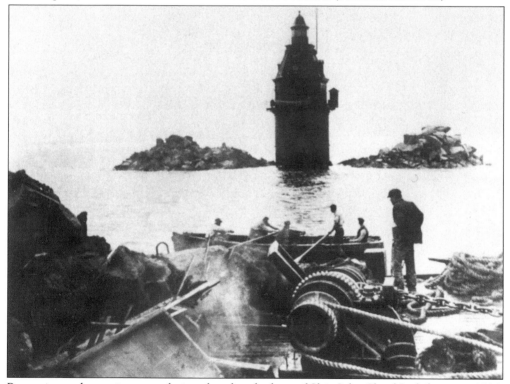

Protective rocks, or riprap, are being placed at the base of Ship John Shoal Lighthouse in 1916. Heavy ice floes in the Delaware River require protection for Ship John Shoal and other lighthouses in the bay. Ship John Shoal is the northernmost of the Delaware Bay lighthouses. On top of its dwelling sits a fourth-order light, rising 56 feet above the water. A fixed red light shone on the day it was completed, August 10, 1877. (Coast Guard.)

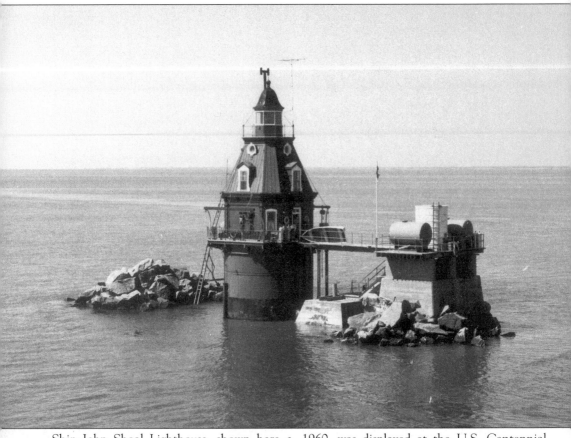

Ship John Shoal Lighthouse, shown here *c.* 1960, was displayed at the U.S. Centennial Exhibition in Philadelphia in 1876 before taking up its duties in the bay. The distinctive light was displayed from a temporary structure beginning in 1874. The 1876 annual report stated that the caisson structure and temporary building were "probably subjected to as severe a test as it ever will be again. It passed through unharmed. The keepers report the vibration of the structure when struck by the ice was so great that they considered it unsafe, and they became alarmed for their personal safety and abandoned their posts on 18 January 1875. Owing to the quantity of ice in the Delaware it was impossible to reach the work again until the 13th of March." (Coast Guard.)

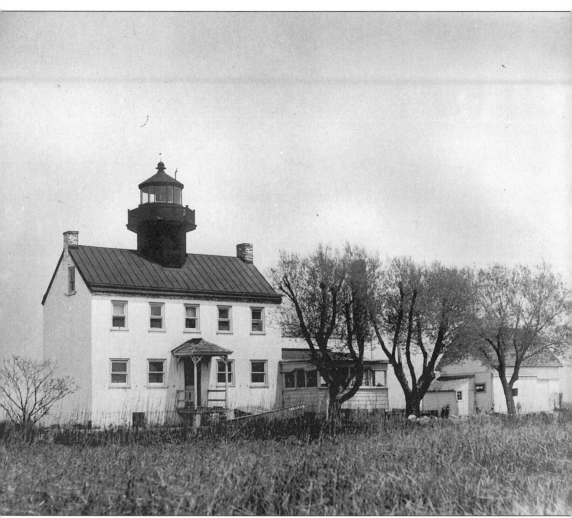

East Point Lighthouse, pictured *c.* 1931, went into service in September 1849. The lighthouse stands on a knoll or a sand island amid a salt marsh. The light is on top of the keeper's dwelling, and is 48 feet above sea level. The annual report noted that "it is of the sixth order, fixed white, supplied with Franklin lamps." The light was discontinued in 1941 or so and became the property of the state in 1956. It is undergoing restoration by the Maurice River Historical Society, based in Millville. (Maurice River Historical Society.)

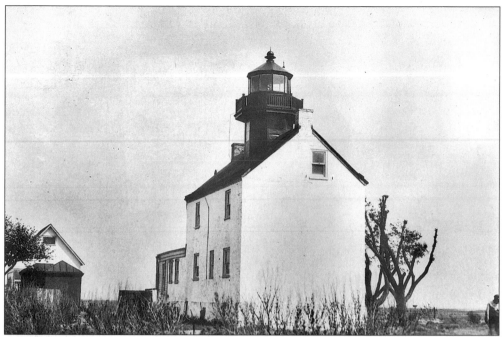

East Point Lighthouse, pictured *c.* 1930, was also known as Maurice River Lighthouse. Joshua Brick sold land at the mouth of the Maurice River to the government on April 11, 1849, for $250. Built by contract in 1849, it was described as "a brick, two-story, and a one-story kitchen adjoining the east end, also used as an oil room. The first story is divided into two rooms and a hall, with stairway to second floor. Second floor also divided into two rooms. There is a cellar under whole house, which is wet in very high tides." (Maurice River Historical Society.)

Maurice River Rear Range Light, pictured in 1913, looked similar to the front light even though it rested on top of the structure and not on a pole extending from it. The lights were connected by a boardwalk with the keeper's dwelling roughly in the middle. It was shown for the first time on October 15, 1898. (National Archives.)

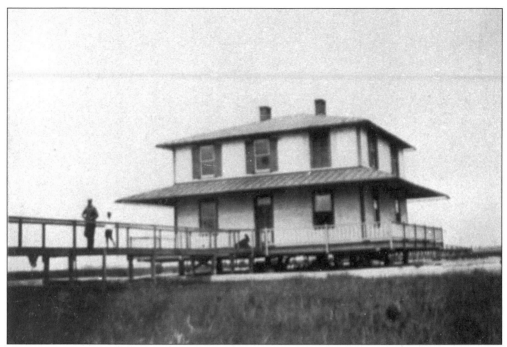

This 1922 photograph shows the keeper's dwelling of Maurice River Range Lights. The 1894 annual report gave the reasons for a range light: "It is claimed that some 500 sailing vessels are engaged in the oyster trade on Maurice river during the season and that they give employment on average to 1,500 men; in addition, a number of coasting vessels visit this river, and the value of this commerce is sufficient to warrant the establishment of range lights to mark the entrance to Maurice River." (National Archives.)

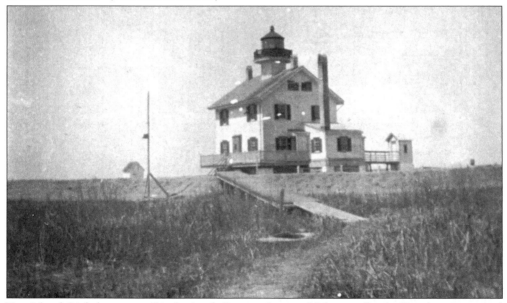

Egg Island Lighthouse in Cumberland County (west of Maurice River Cove) was situated between there and Delaware Bay on land known as Egg Island Point. This photograph dates from c. 1893. (Coast Guard.)

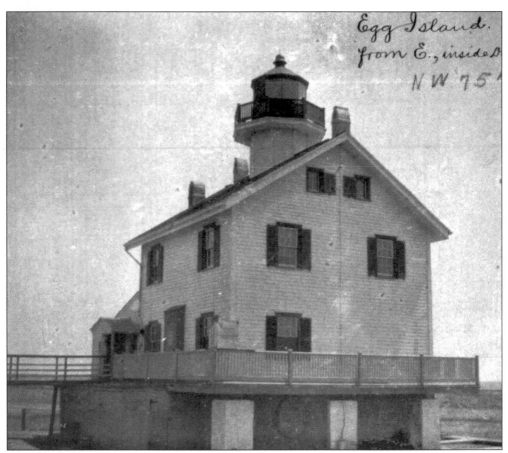

Egg Island Light Station, shown c. 1900, was established in 1838. The lighthouse was rebuilt on a screw-pile foundation. The fifth-order light was exhibited for the first time from the new lantern on July 24, 1867. The light warned of mud flats and shallow water south of it. Because of encroaching water, the lighthouse was moved back about 1,000 feet in 1878. In 1938 or 1939, the light was removed from Egg Island Lighthouse's rooftop tower and placed on a nearby metal-frame tower. On August 20, 1950, the abandoned Egg Island Lighthouse was destroyed by a fire that is believed to have been set accidentally by fishermen. Like Cohansey Light on the Cohansey River, Egg Island Light primarily served local vessels, especially the oyster fleet. At one time New Jersey had a major oyster fishery served by hundreds of boats. (National Archives.)

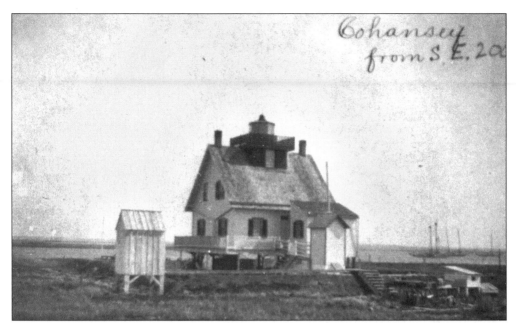

Cohansey Lighthouse was located near the junction of the Cohansey River and Delaware Bay in a salt marsh. The river, leading to the then-busy ports of Greenwich and Bridgeton, served bay men. The first lighthouse was built in 1838. The 1855 annual report says, "a fifth order lens introduced in place of seven lamps, and it was also fitted with superior French plate glass." The report also noted that "Cohansey will only serve a local purpose when the Ship John Shoal Lighthouse is completed." But Ship John Shoal Lighthouse was not built until 1877. This photograph dates from 1897. (National Archives.)

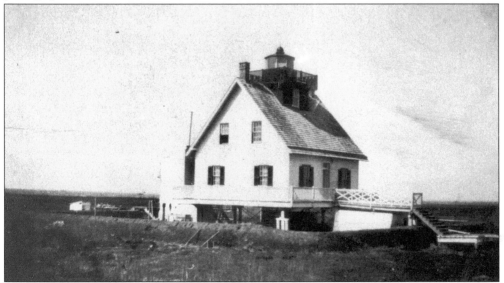

Cohansey Lighthouse, seen here in 1913, was rebuilt in 1883 and had a fifth-order lens. The 1888 annual report notes that a red sector was to be introduced into this light, "covering an angle of 42 degrees so as to give a well-defined line for keeping vessels off Ben Davis' Shoal and to guide into the cove and mouth of the river." The lighthouse was destroyed by a fire in July 1933, but its light had been long before moved to a skeleton tower. (National Archives.)

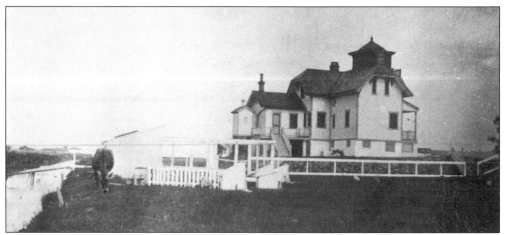

Finns Point Front Range Lighthouse is pictured here in June 1928. The deed of April 19, 1876, described the property in Lower Penns Neck, Salem County, as 6 acres of meadow and 4 acres of water. The range lights were first displayed on April 2, 1877, from a frame tower above the keeper's residence. Encroaching water was a constant problem, and the light was finally removed from the building and placed on a small tower in 1938. The lighthouse was torn down in 1939. (Coast Guard.)

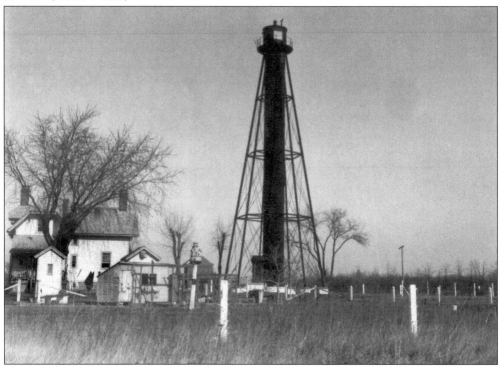

Finns Point Rear Range Lighthouse is shown as it appearing in January 1933. The 115-foot iron tower adjacent to Fort Mott in Salem County still stands. The light was approximately 1.5 miles from the front light. The circular column in the center of the frame holds the stairway. The structure is painted black. The range lights were discontinued in 1950 because the redredged channel was in a different position and other aids to navigation took their place. (Coast Guard.)

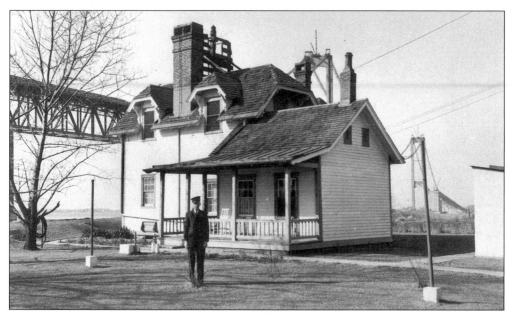

In this January 1951 photograph of Deepwater Point Front Range, note the construction of the Delaware Memorial Bridge in the background. When finished late in the summer of 1951, the bridge blocked the view of the range, ending its useful life. The building was torn down in 1956. The keeper was Ferdinand Heizmann. The range lights were first shown on November 15, 1876. The front range was a fourth-order lens located in the second story of the building. (Coast Guard.)

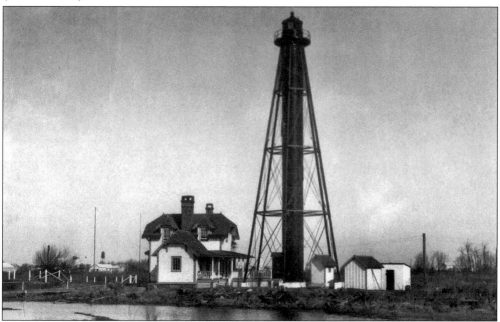

Deepwater Point Rear Range, as it appeared in 1933, marked the channel where the river passes Bulkhead Shoal. The front lighthouse was about 3.75 miles below Penns Grove. The tower is similar to Finn's Point Rear Range Light. The rear range was dismantled sometime in the 1950s and the site is now heavily industrialized. (Coast Guard.)

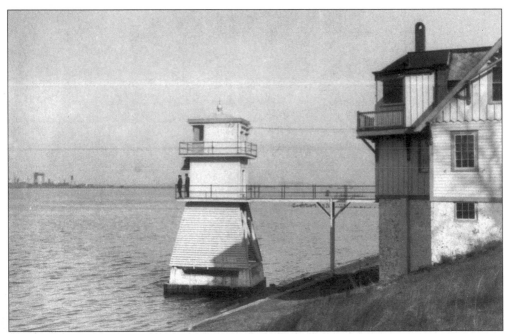

Fort Mifflin Bar Cut Front Range Light, pictured in January 1933, was also known as Billingsport Light. The front light building housed two lights, pointing in opposite directions, and served as the front range for both Tinicum Island and Fort Mifflin Bar Cut Rear Range Lights. The range went into operation on December 31, 1880. The 1879 annual report said, "These lights when completed will in connection with the range lights now lighted mark the channel perfectly between Ship John Shoal and League Island." (Coast Guard.)

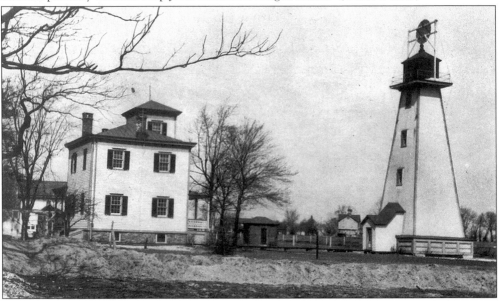

This is how Fort Mifflin Bar Cut Rear Range appeared in March 1913. The initial light was on the top of the keeper's dwelling, but trees obscured it and so the pyramidal tower was erected to hold the light in 1886. The rear light, which was in Paulsboro, was torn down in 1953, and an oil refinery now covers the site. The lights still operate from steel towers. (Coast Guard.)

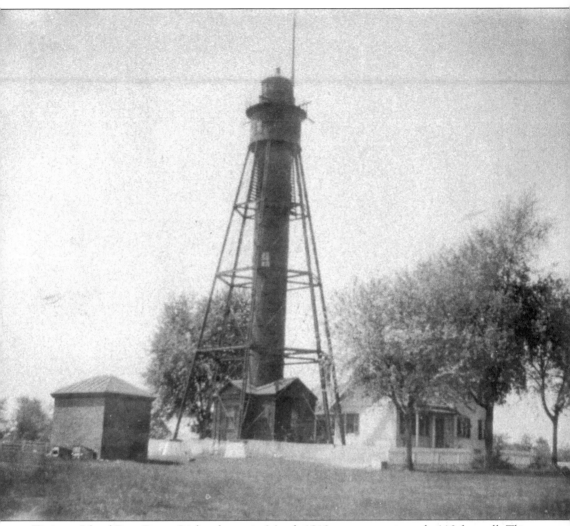

Tinicum Island Rear Range Light, shown in March 1913, was approximately 110 feet tall. The tower still stands in the Billingsport section of Paulsboro and is an active aid to navigation maintained by the Coast Guard. The 1879 annual report noted that the range "guides [ships] through the reach passing Tinicum Island and in connection with the front light of Tinicum Island Range will form a range through the dredged channel across Fort Mifflin Bar." Tinicum, Deepwater Point, and Finns Point Rear Range Lights were all designed in the same steel tower style with a center enclosed stairway. The Lighthouse Service on a number of occasions used the same plans for several different lighthouses. (Coast Guard.)

The Horseshoe Shoal Range Light, Upper Front East Group, is shown here in 1913. This is an unusual range because it consists of three lights instead of two, although the piloting principles are the same. The rear light is lined over the front light, but lights from both the East and West Group must be used in making turns through Horseshoe Bend and in avoiding Horseshoe Shoal, below Philadelphia. The East Group is on the New Jersey side of the river. (Coast Guard.)

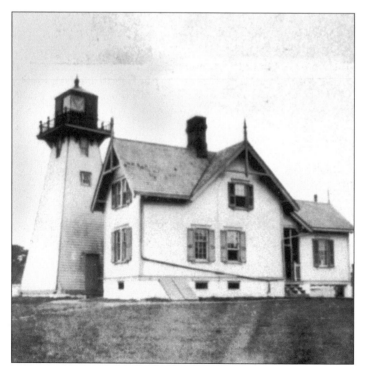

This is Horseshoe Range Rear Light, East Group, as it looked in January 1933. The ranges on both sides of the river were first lighted on October 1, 1881. They consist of lower fronts, upper fronts, and rear lights on both sides of the river, with two red lights and four white lights. Changes in the shipping channel and other improved aids to navigation made the East Group obsolete, and their lights were discontinued. (Coast Guard.)

Five

LIGHTSHIPS

Lightships were vessels forever fated to cruise to nowhere, riding at anchor to cast their protective beam of light over offshore shoals or as floating lights that marked the approaches to major ports.

In 1820, the first lightship was tethered to the bottom of Chesapeake Bay in Virginia. The first open-seas one was *Sandy Hook Lightship*, established in 1823. New Jersey's lightships were vital in the continuation of lights up the Atlantic coast, marking the way north to New York or south to Philadelphia. These lightships that marked ocean passages were known as outer lights. The largest number of lightships that were ever on station at any one time peaked at 56 in 1909. At various times, however, the United States had 116 lightship stations between 1820 and 1985. The last such station was *Nantucket Shoals Lightship*, replaced by a large buoy in 1985.

New Jersey had six light vessel stations, ranging from north to south: *Sandy Hook* (later renamed *Ambrose* and moved to a new position), *Wreck of the Scotland*, *Barnegat*, *Five Fathom Bank*, and *Northeast End*. In Delaware Bay were *Brandywine Shoal* and *Cross Ledge*, which was also known as *Upper Middle Light Vessel*.

Like lighthouses, the official name of light vessels is "light station." At any station, a number of lightships served. Lightships were unromantically referred to by number, such as LV 87, which served as *Ambrose Lightship* from 1908 to 1932. Between 1942 and 1965, the Coast Guard used the prefix WAL for lightships. After that, they used WLV.

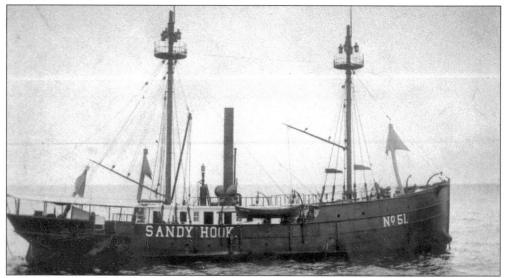

Sandy Hook Lightship, LV 5, was established on the station in 1823, making it the oldest offshore light vessel station in the country. LV 51, which had the first steel hull for the service, was built in 1892 at a cost of $53,325. It served at Sandy Hook from 1894 until the station ended in 1908. It then became a relief vessel in the Third District. It was rammed by a barge and sank in Connecticut waters in 1919. (Coast Guard.)

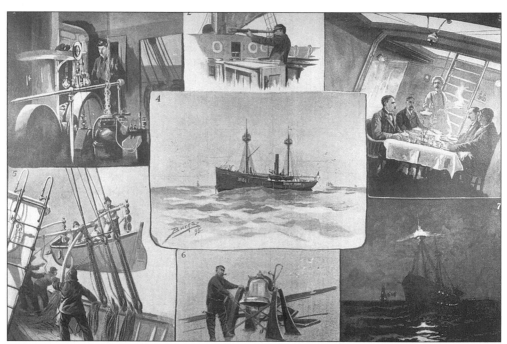

This *Harper's Magazine* illustration shows various activities aboard Lightship 51, *Sandy Hook*. Completed by 1892, this was the first lightship in the country to use electricity to power its lights. Pictured from left to right are the following: (top row) the dynamo room, a lookout, and the crew in the ship's mess hall; (middle row) the ship on station; (bottom row) a lifeboat drill, the bell sounding in fog, and the vessel lighted at night. (Twin Lights Historical Society.)

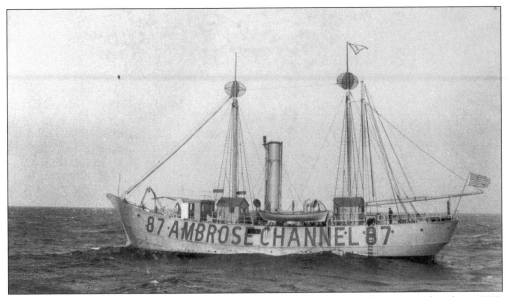

This photograph of LV 87 dates from 1909. When *Ambrose Channel* was completed in 1908, the Sandy Hook station ceased and Ambrose Station took its place, but farther out. On June 24, 1960, a relief lightship was hit by a freighter and sank, but all nine of the crew were saved. LV 87 was built in Camden in 1907, served at *Ambrose* from 1908 to 1932, and later became *Wreck of Scotland Lightship*. It is now at South Street Seaport Museum in New York. (Coast Guard.)

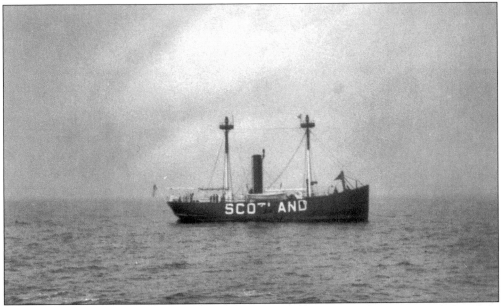

LV 11, a wooden ship built in 1853, served as *Wreck of the Scotland Lightship* from 1902 to 1925. The lightship marked the wreck site of the steamer *Scotland*, which sank in a December 1866 collision with the schooner *Kate Dyer*, some 2.5 miles from Sandy Hook Lighthouse. The wreck was eventually moved, but the lightship had become an important marker for New York Harbor and stayed on station until 1962, when a buoy took over. (Coast Guard.)

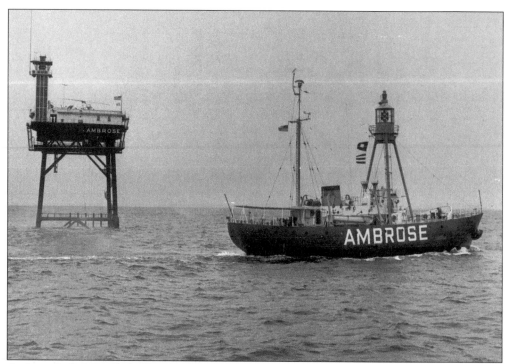

Ambrose Lightship sailed off station on August 23, 1967, having been replaced by a 132-foot, $2.5 million Texas tower-style light, left. The lightship WLV 613 was the sixth and last vessel to serve there, replaced for reasons of economy, efficiency, and (in Ambrose's case) safety. Later, the vessel built in 1952 became the country's last serving lightship when it left Nantucket Shoals Station in 1985. It is now a floating museum in Boston. Its successor, Ambrose Tower, was hit and damaged in September 1997 by a freighter, and was replaced by a new tower, shown below, in September 1999. Vessels such as WLV 613 were anchored in areas too hazardous or too deep to build lighthouses based on existing 19th- and early 20th-century technology. As the technology advanced in the later part of the 20th century, lightships were replaced by either a large buoy or a Texas tower. (Coast Guard.)

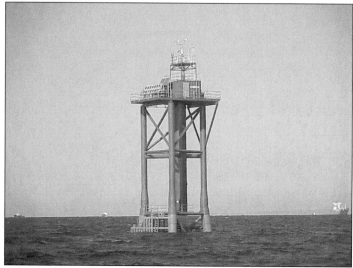

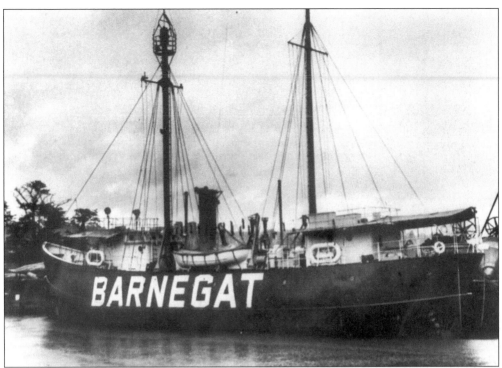

LV 79, shown at dock, was on Barnegat station from 1927 to 1942 and again from 1945 to 1967. *Barnegat Lightship* station existed from 1927 to 1969, 8 miles east of Barnegat Inlet. It helped vessels stay clear of shoals and was an outer beacon for navigation along the coast, more effective than the lighthouse. The lightship was replaced in 1969 by a lighted buoy. LV 79 was built in Camden in 1904 for $89,030 and was steam driven. (Coast Guard.)

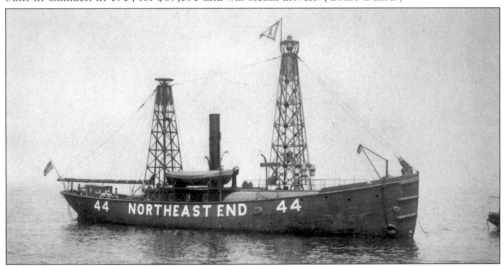

LV 44 served as the Northeast End Lightship from 1882 to 1926. Established in 1882, the station was located 12 miles east of Hereford inlet, marking the northeast end of the Five Fathom Bank Shoal. The station was decommissioned in 1932. LV 44 was built in Wilmington, Delaware, for $50,000 in 1882. It had an iron hull and two masts with distinctive lattice daymarks. It was the first U.S. lightship with an all-metal hull. (Coast Guard.)

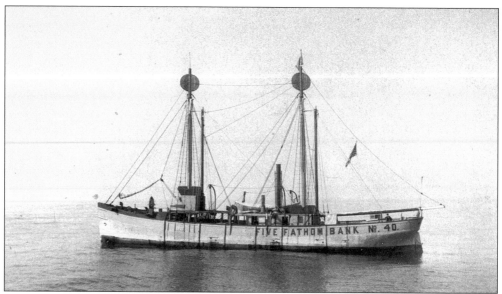

LV 40 was on Five Fathom Bank from 1877 to 1904. It was schooner-rigged, built of oak in 1875, and held in position by a 700-pound mushroom anchor. On August 23, 1893, its relief lightship, LV 37, sank in a storm when high waves began breaking over the vessel, rolling it, and tossing the crew overboard. Four of the six crewmen died. This incident marked the first time a lightship had sunk without being hit by another vessel. LV 37 was also a wooden sailing ship, built in 1869. (Coast Guard.)

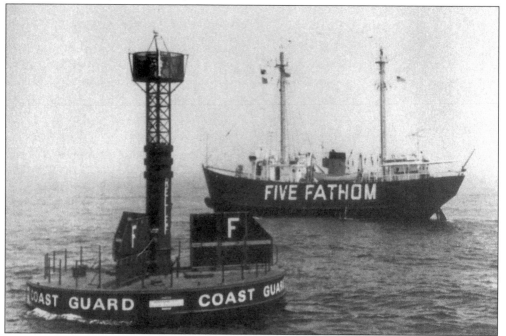

Five Fathom Bank Lightship was replaced by a large navigational buoy in 1972, both seen here. The station was established in 1839 to mark the entrance to Delaware Bay and to warn of a shoal area. WLV 189 only served for a year on Five Fathom Bank, but it was the last lightship assigned there. It was built in 1946. (Coast Guard.)

Six

THE U.S. LIFE-SAVING SERVICE

Today, the U.S. Life-Saving Service is a largely forgotten federal agency. Were it not for some quaint buildings left behind, the service might have disappeared from our collective consciousness. It was not always that way. During the agency's peak years, from 1878 to 1915, lifesavers were popular folk heroes depicted as "Storm Warriors" in magazines. Their courage was symbolized in the phrase, "the regulations say you have to go out, they don't say you have to come in."

Part of the reason for strong public support of the Life-Saving Service came from its vividly written annual reports, which always featured stories of dramatic rescues. Early on in his tenure, the general superintendent of the service hired a former newspaperman to write the reports. Excerpts from the 1890 annual report, describing the wreck of the bark *Germania* off Long Branch, illustrate the writing style: "Breakers ahead. The mate ran quickly on deck, and seizing the wheel to bring the vessel's head around; but it was too late, at that moment she struck 200 yards from shore and the great seas from that moment rushed against and over the doomed craft." Ten of the 13 crewmen aboard the bark died.

The Life-Saving Service traces its roots to New Jersey in 1848 when Congress appropriated $10,000 for "providing surfboats, rockets, carronades and other necessary apparatus for better preservation of life and property from shipwrecks on the coast of New Jersey lying between Sandy Hook and Little Egg Harbor." The stations were manned by volunteer crews.

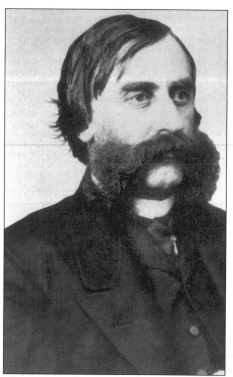

New Jersey Congressman William A. Newell (2nd District, Allentown area) appears in this undated photograph. In an August 3, 1848 speech before the House of Representatives, Newell was instrumental in pushing through the $10,000 appropriation for life-saving buildings and equipment, marking the feeble beginning of the Life-Saving Service. A physician and politician, Newell said he became interested in the plight of shipwreck victims after witnessing the destruction of the Austrian bark *Terasto* on Long Beach Island on August 13, 1839. Newell was also governor of New Jersey from 1857 to 1860. (National Archives.)

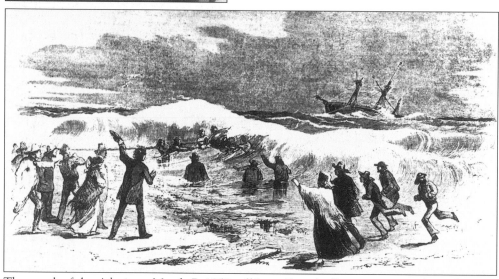

The wreck of the *Adonis* on March 7, 1859, off Long Branch illustrates a typical wreck scene, with volunteers and bystanders struggling to render aid to the ship stranded a few hundred yards from shore. While all were saved from the *Adonis*, two dramatic wrecks with many fatalities occurred 1854: the *New Era* and the *Powhattan*. These wrecks showed that the volunteer system was inadequate. Headlines from the April 20, 1854 *New York Times* tell the story: "Great Loss of Life. Emigrant Ship Cast Away on Absecon Beach. Loss of the *Powhattan* of Baltimore. 58 Bodies Washed Ashore. Steam Tugs Dispatched from City." About 300 people died in this wreck, another 300 in the wreck of the *New Era*. The artist of this rendition is unknown. (Rutgers University Libraries Special Collections.)

Douglas Ottinger, a Revenue Cutter Service captain, appears in this undated 19th-century portrait. In 1848, Ottinger—along with representatives from the Life-Saving Benevolent Association of New York, founded by marine insurers—selected sites for the eight initial -saving stations in New Jersey. In 1849, six sites in southern New Jersey were added, selected by the Revenue Cutter Service's Lt. John McGowan and a committee from the Philadelphia Board of (marine) Underwriters. (Coast Guard.)

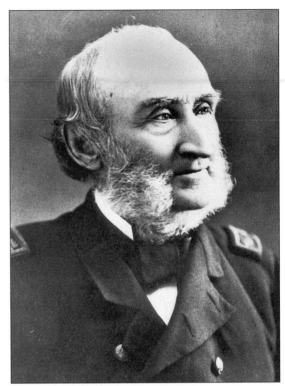

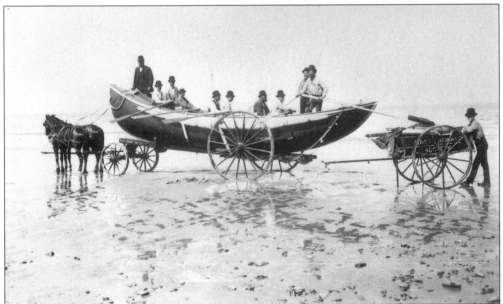

A surfboat from the Humane Society of Massachusetts is shown in this undated 19th-century photograph. America's first organized attempt to save shipwreck survivors came in 1791 when the Humane Society of Massachusetts erected a hut on Lovell's Island in Boston Harbor to shelter shipwreck survivors. In 1807, the society built the country's first lifeboat station in Cohasset. The Massachusetts society had close relations with its British counterpart and first introduced British self-bailing, self-righting lifeboats to this country. (Coast Guard.)

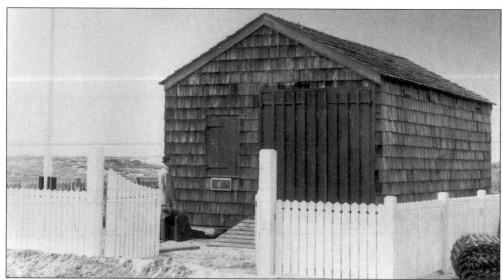

The first life-saving station built with federal funds (in 1848) was originally located in Spermaceti Cove on Sandy Hook. It was moved to nearby Twin Lights State Park in the late 1950s or early 1960s, where the nation's first Coast Guard station still stands. It is shown here *c.* 1950 at its Sandy Hook location. Boathouses like this were built at Spermaceti Cove, Monmouth Beach, Deal, Spring Lake (then called Wreck Pond), Chadwick, Island Beach, Bonds (Beach Haven), and Harvey Cedars. (Twin Lights Historical Society.)

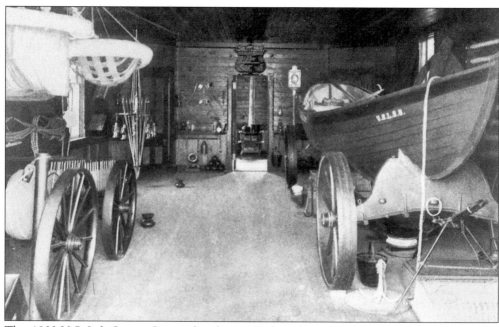

This 1903 U.S. Life-Saving Service boathouse displays the variety of equipment stored at life-saving stations for rescues. A typical station had a surfboat mounted on a hand-pulled carriage, a life-car, and a mortar to fire a line to a stranded ship in order to rig it for rescue by the breeches buoy or life-car. Each station also had a beach cart that held the rigging and other gear for the breeches buoy, as well as shovels and reels of line. (Twin Lights Historical Society.)

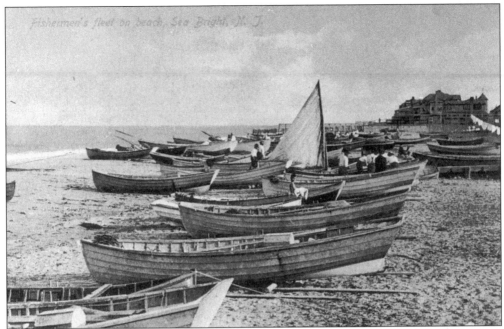

Fishing skiffs line the shore at Sea Bright at the start of the 20th century. These boats, used by surf fishermen, were launched from the beach through the waves to the inshore fishing grounds. The Sea Bright skiff was adopted as the Life-Saving Service's official surf rescue boat in May 1872, following a conference of Naval and Treasury Department officials at the Sea Bright Life-Saving Station. The boat, made from cedar, was also widely used by New Jersey's coastal wreckers. (T.J. MacMahon.)

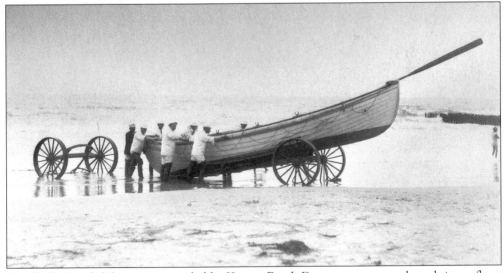

The Holly Beach life-saving crew, led by Keeper Frank Downs, prepares to launch its surfboat c. 1900. A surfboat is different from a lifeboat. A surfboat is smaller and lighter and can be pulled on a wheeled carriage to the wreck site. At the site, the surfboat is launched from the beach and through the breakers to the shipwreck. Heavier and larger lifeboats were generally launched from ways into bays or other protected waters. (Friends of the Ocean City Historical Museum Inc.)

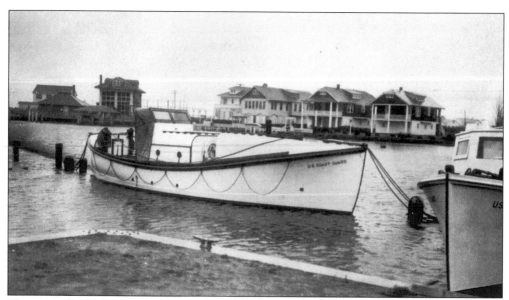

This motor lifeboat is seen at the Ocean City Coast Guard station in 1934. In about 1900, the Life-Saving Service began experimenting with motors for lifeboats and surfboats. The lifeboats, before they had motors, looked very similar to this one, modeled after British self-bailing and self-righting lifeboats. The lifeboats were 30 to 35 feet long and weighed up to 4,000 pounds; surfboats were 25 to 28 feet long and weighed from 800 to 1,100 pounds. Both were rowed or pulled by oars, hence the name "pulling boats." (Coast Guard.)

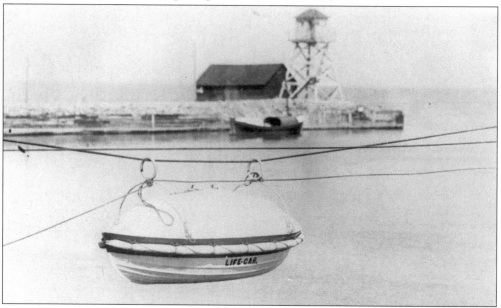

The life-car shown in this undated photograph, was invented by Joseph Francis in the 1840s. Francis lived in Toms River and was a boatbuilder for Novelty Iron Works in New York City. The life-car proved its worth to the Life-Saving Service after one of the galvanized metal cars saved 200 people from the *Ayshire* wreck off Manasquan on January 12, 1850. Carried through the waves on a pulley system, the life-car ran between the wrecked ship and shore. (Coast Guard.)

Sumner Kimball, former Maine attorney and state legislator, was in charge of the Revenue Cutter Service when appointed to head the U.S. Life-Saving Service in 1871. He was the service's only general superintendent, retiring at age 83 in 1915. He was instrumental in creating a professional, disciplined service. He used a dual-track administration with civilian regional superintendents overseeing day-to-day operations, while Revenue Cutter Service officers served as inspectors to ensure crews were well-drilled and stations were in good order. (Coast Guard.)

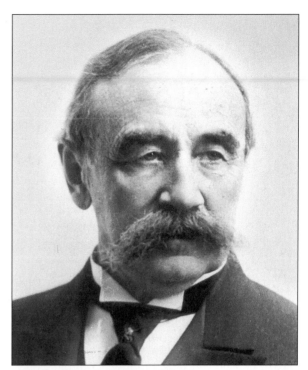

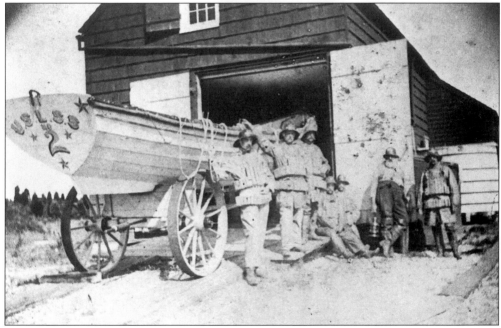

Lifesavers, shown here c. 1885, were generally recruited local fishermen who knew surf and sea conditions in their area. In 1854, following the disastrous wrecks of the *New Era* and *Powhattan*, the volunteer service (created in 1848) was upgraded with keepers hired for $200 a year for the 28 life-saving stations in New Jersey and the 27 on Long Island. Superintendents were also hired to oversee them. This system limped along until 1870, when crews of six men were hired for the three winter months at alternate stations in New Jersey. (Coast Guard.)

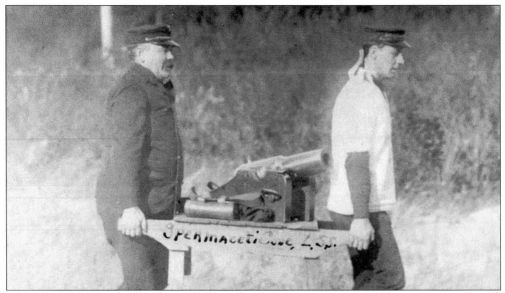

This February 1900 photograph shows keeper Joel R. Woolley on the left and surf man James Mulligan of Spermaceti Cove station carrying a Lyle gun. By 1875, lifesavers were on duty five months of the year at every station, from November 1 to April 1. This and other reforms took place in the wake of a 1871 report by Revenue Cutter Service Capt. John Faunce, who was asked by Sumner Kimball to investigate the service. Faunce wrote, among other things, that "most of the stations were too remote from each other, and the houses were much dilapidated." (Twin Lights Historical Society.)

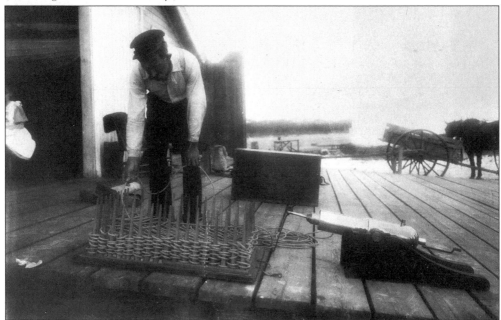

This unidentified photograph shows a Lyle gun and a box holding the line fired to ships in distress, called a faking box. Following Capt. Faunce's 1871 report, 12 new boathouses were built and some stations were relocated. The goal was to have a station every 3 miles along the New Jersey coast. (Coast Guard.)

These Coast Guardsmen demonstrate a Lyle gun, a line-throwing mortar, that shot a window-weight-sized projectile with attached line up to 500 yards to a wrecked ship. The ship's crew then pulled the light line with a hawser attached and made the large line fast to their lower mast, while the life-saving crew set up a wooden frame on the beach and sent the breeches buoy to the ship. (Ocean County Historical Society.)

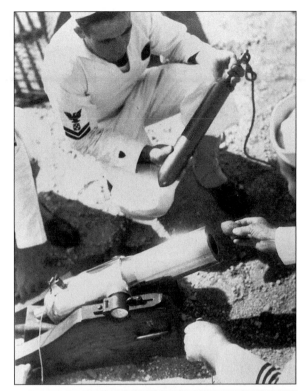

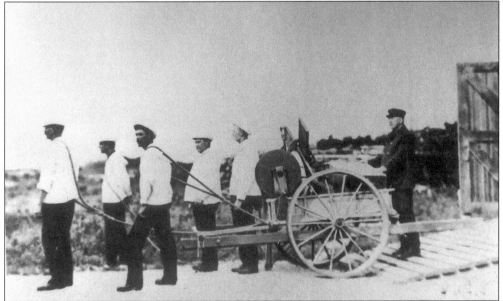

The Little Egg (Tucker's Beach) life-saving crew pulls a beach apparatus cart, containing breeches buoy and other equipment, in this c. 1900 photograph. Except for those fortunate few stations with horses, most equipment was manhandled through the sand on a beach cart to the wreck site. In 1872, to increase the efficiency of life-saving efforts, a Board of Life-Saving Apparatus was set up; the board met each year in Boston to evaluate new rescue equipment. (Ocean County Historical Society.)

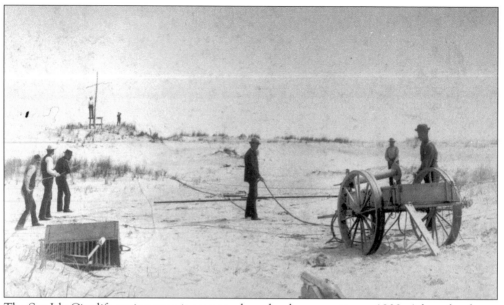

The Sea Isle City life-saving crew is seen at a breeches buoy practice *c.* 1900. A breeches buoy, as its name implies, consists of an oversized pair of canvas pants stitched to a cork life-saving ring. Invented in England, it was preferred over the life-car because it carried people to safety above rather than through the waves. It was also safer for the rescue crews than an open surf boat in rough water. (Friends of Ocean City Historical Museum Inc.)

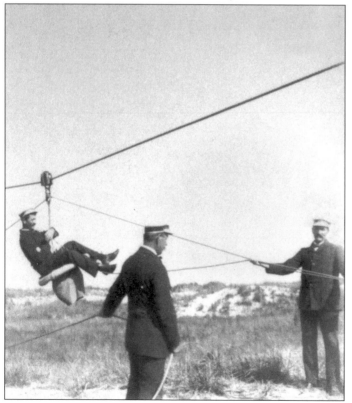

In this *c.* 1900 photograph, the Ocean City life-saving crew participates in breeches buoy practice. At the time, lifesavers were on duty ten months of the year, from August 1 to May 31, and were paid $65 a month. The number one surf man, who must be able to step in and take the keeper's place, was paid $70. Keepers were appointed from the ranks of surf men, and superintendents from the keeper positions. Keepers had to live constantly at their stations and were paid $1,000 annually. (Friends of Ocean City Historical Museum Inc.)

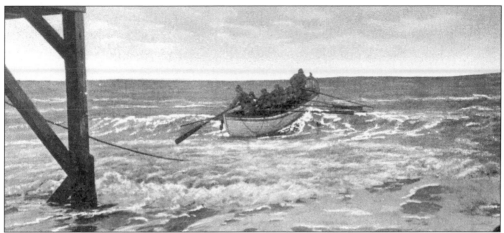

This early 1890s postcard shows the Atlantic City life-saving crew launching its surfboat. When Sumner Kimball took over the Life-Saving Service in 1871, he established a set weekly routine: Sunday was a day for rest or religion; Monday, for putting the station and gear in order; Tuesday, for practice launching the surfboat through the waves; Wednesday, for practice communicating with international signal flags; Thursday, for drill with the breeches buoy and other beach apparatus; Friday, for practice of artificial respiration, or as it was then called "restoring the apparently drowned;" and Saturday, for doing the wash. (Inlet Public-Private Association.)

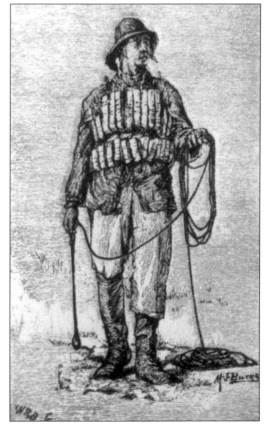

This illustration shows a lifesaver wearing an old-style jacket and holding a weighted line known as a heaving stick. For close-in rescues, lifesavers threw a heaving stick—a weight on one end of a stick with a line attached to the other end—to the crew of the stranded vessel. The line was then brought aboard, and the breeches buoy system was rigged onshore to bring people off the stricken vessel. This method of throwing a line to a ship was effective for a distance of about 50 yards. (Coast Guard.)

The Sea Isle City life-saving crew practices righting the surfboat, c. 1900. The capsizing drill, a warm-weather part of Tuesday's boat drill, was important because surfboats, while self-bailing, were not self-righting. The drill was also dangerous. A 1914 report on how surf men died revealed that a number of them were killed in boat drills. The vast majority, however, died of disease contracted while on duty. (Friends of Ocean City Historical Museum Inc.)

This unknown crew practices artificial respiration. In 1889, the Life-Saving Service became a uniformed one because of complaints. Many complained that rescuers could not be identified at shipwrecks and that they scared victims whom they came to save when boarding foundering ships or when firing rescue mortar from shore. The men's pleasure at having uniforms was short-lived when they learned that they had to pay for them. (Ocean County Historical Society.)

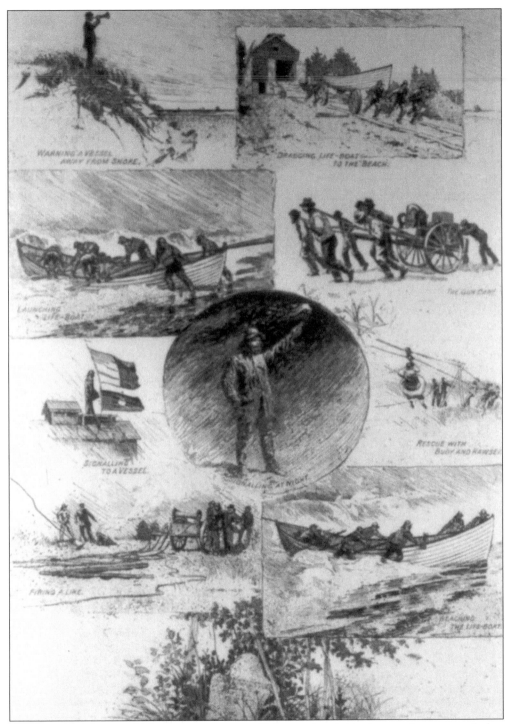

This *Harper's Magazine* 19th-century montage of lifesavers' activities is a good summary of what the job entailed. Although many of the policies and practices of the Life-Saving Service were fixed after 1871 when Sumner Kimball took over, the service was not officially created as a separate bureau within the Treasury Department until 1878. (National Archives.)

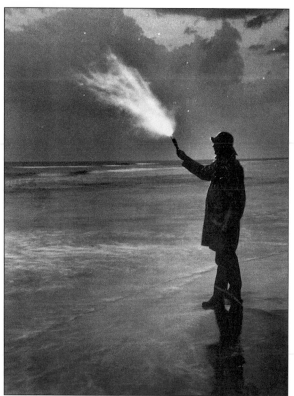

A lifesaver on beach patrol displays a coston, a red flare that let ships in distress know that they have been spotted. Beginning in 1871, surf men where required to maintain beach patrols at night and on stormy days to search for shipwrecks. During the day, they stood watch in their station's tower. To ensure the patrols made their rounds, a surf man carried a token with his station's name on it. The surf man exchanged the token midway between stations with his counterpart from the adjacent station. (National Archives.)

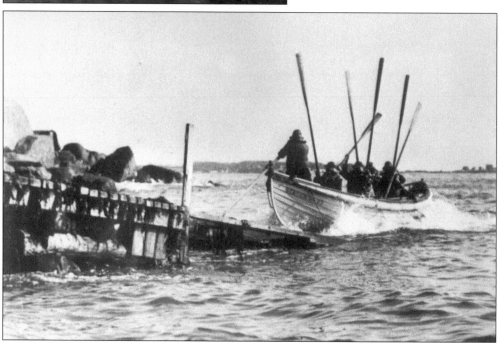

This lifeboat rides down the launch way at Tucker's Beach life-saving station *c.* 1900. Note the number 23 on its stern, which was the Life-Saving Service's designation for Little Egg Station on Tucker's Beach. (Coast Guard.)

Seven

LIFE-SAVING STATIONS: SANDY HOOK TO CAPE MAY

The approximately 20 Life-Saving Service buildings that remain along the Jersey shore come from four basic periods or styles, with only one or two exceptions. The buildings of the first style, the 1882 buildings, feature a prominent center-of-the-roof tower. Ocean City is a good example (one of the four built in the state). The next step in the evolution of station architecture is known as Bibb No. 2, named after designer Albert Bibb, with nine stations built here between 1886 and 1891. An example can be seen in the Kiwanis Club building in Cape May, the former Cold Spring Life-Saving Station.

The next period is known as the Duluth style, named after the Minnesota city where the first station was built. Designed by architect George R. Tolman, these stations feature a tall, square tower integral to the structure. Eleven of them were built here between 1894 and 1908. The visitor's center at Spermaceti Cove, the Sandy Hook section of Gateway National Recreation Area, is a good example of the Duluth style. Fittingly, the last style of stations is known as Jersey Pattern, designed by architect Victor Mendleheff. These stations feature a short eight-sided tower. The maintenance yard at Island Beach State Park has a Jersey Pattern building on its grounds.

All of the photographs in this chapter come from the U.S. Coast Guard collection, unless specified otherwise. Most are undated but stem from the 1930s and 1940s. The number in brackets before the name in captions was the station's U.S. Life-Saving Service designation prior to 1883; after that, stations were called by name. The number after the name, is the Coast Guard's number for the facility. The Coast Guard started its numbering system c. the early 1920s.

This is an 1856-style station. These stations were built at Sandy Hook, Long Branch, Squan Beach (Manasquan), Toms River, Forked River, Barnegat, Ship Bottom, Little Egg, Atlantic City, Great Egg, Corson's Inlet, Tatham's (Stone Harbor) Turtle Gut (Wildwood), and Cape May.

This 1871-style station, or red house, was so named because of its exterior color. These stations were 42 feet long, 18 feet wide, and had four rooms—two on each floor. On the ground floor, one room held boats and other equipment and the other room served as a mess hall. On the upper floor, one room held lighter rescue apparatus, and the other—like a firehouse—had cots for sleeping. These stations were built at 38 locations in New Jersey, replacing earlier stations and also expanding coverage.

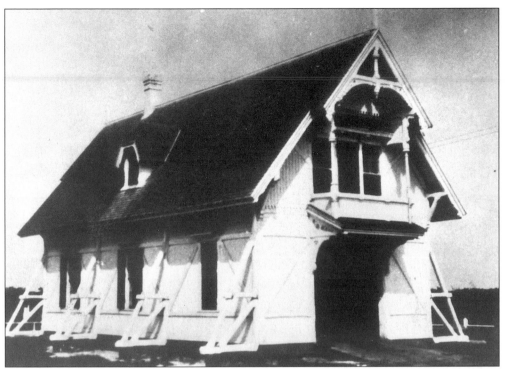

The 1876-style stations, more ornate than their predecessors, were the first ones built with a consideration of aesthetics as well as functionality. One still stands in Long Branch, and others were built at Sea Bright and Cape May. They were designed by architect Francis W. Chandler.

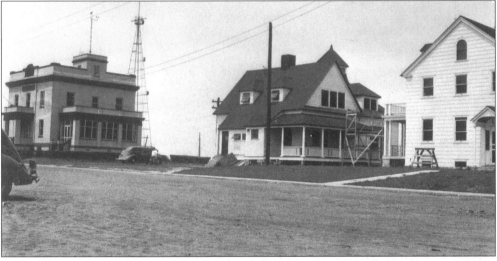

In this 1937 view, the building on the left is a Weather Bureau facility located next to the Sandy Hook Life-Saving Station. In 1870, the U.S. Army Signal Service (predecessor to the Signal Corps) created a weather forecasting arm that lasted until 1890, when it was transferred to the Agriculture Department. The Signal Service had weather stations in 25 major cities and along the coasts at selected life-saving stations. In New Jersey, Signal Service men were were at Sandy Hook, Monmouth Beach, Squan Beach, Barnegat, Atlantic City, Peck's Beach (Ocean City), and Cape May.

[1] Sandy Hook Station, CG 97, was on the bay side near Sandy Hook lighthouse on the military reservation. It opened in 1848 and is still in operation, although no period buildings remain. The structure was moved several times within the same general area. Keepers included Aaron Brower (1856), Charles Patterson (1872), John C. Patterson (1876), Trevonian Patterson (1883), Chester A. Lippincott (1908), and Loren Tilton (as acting keeper, 1915).

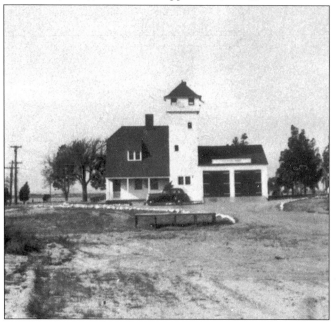

[2] Spermaceti Cove Station, CG 98, still stands 2.5 miles south of Sandy Hook Lighthouse. It was opened in 1849 and closed in 1922. Keepers included Nathan Woolley (1849), William Casey (1853), William Childs (1856), Samuel Warner (1869), Curtis W. Tallman (1875), John Kittle (1877), J.N. Edwards (1879), and Joel R. Woolley (1900, still serving in 1915).

[3] Sea Bright Station, CG 99, is now a private residence. One mile south of Twin Lights, it opened in 1871 and closed in 1937. The lookout tower remained active until 1946. Keepers included Charles West (1872) and Albert West (1874).

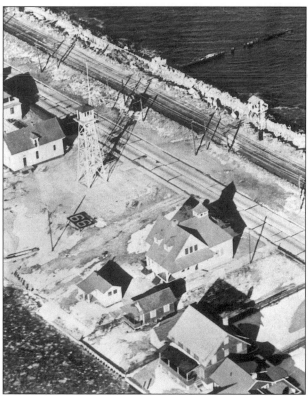

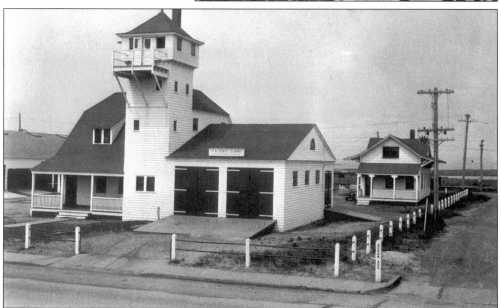

[4] Monmouth Beach Station, CG 100, still stands as a town-owned structure. About a mile south of Sea Bright, the first station was built in 1857. It closed in 1964. It was moved back because of encroaching seas. Keepers included Edward Wardell (a well-known wreck master who started in 1857), Charles H. Valentine (1875), James Mulligan (1884), and George W. Green (1905, still serving in 1915).

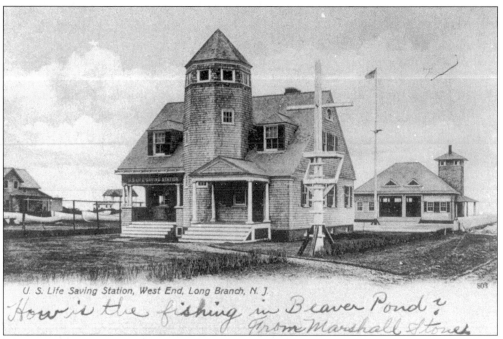

U. S. Life Saving Station, West End, Long Branch, N. J.

How is the fishing in Beaver Pond?
From Marshall Stone

[5] Long Branch Station, CG 101, is still standing with stations from three different periods on the property at Green Pond in Long Branch. The station operated from 1849 to 1954. Its keepers included Charles Green (1856), Hamilton Taber (1871), Walter S. Green (1879), Asher Wardell (1886), and William Van Brunt (1904, still serving in 1915).

The Deal keeper sits at his desk *c.* 1900 in a station designed by the well-known architect Paul J. Pelz, who also designed what is now called the Jefferson Building of the Library of Congress. Pelz designed similar stations for Bay Head and Atlantic City, which featured distinctive, tall towers.

94

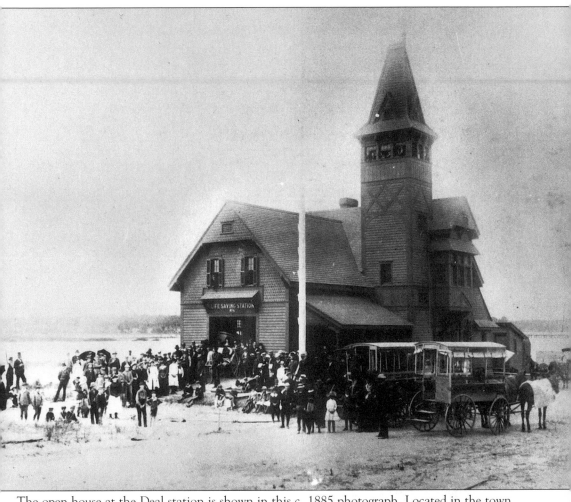

The open house at the Deal station is shown in this *c.* 1885 photograph. Located in the town of Deal, [6] Deal Station, CG 102, remains today. The first station, one of the original eight, was built in 1849. In 1881 or 1882, a new station was built because of a dispute over title to the property. The station was discontinued on February 6, 1940. Some of its keepers were Abner Allen (1849), John Slocum (1879), Lambert Edwards (1882), Benjamin Van Brunt (1895), and William Van Brunt (1915).

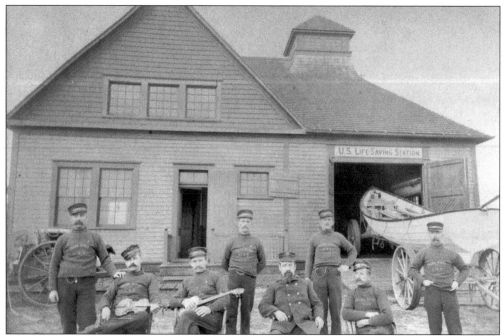

The 1890 photograph above shows [7] Shark River Station, CG 103. It is listed as near the mouth of Shark River, Avon-by-the-Sea. The first station was built in 1871, rebuilt in 1872, and relocated in 1885. Although no period buildings remain, the station is still in seasonal operation. The photograph below shows how the station looked in 1961. Its keepers included William A. Hawey (1872), Job Edwards (1875), John Kittel (1879), John C. Patterson (1883), John Redmond (1886), John H. Pearce (1889), David Yarnell (1905), and Charles Chasey (as acting keeper, 1915).

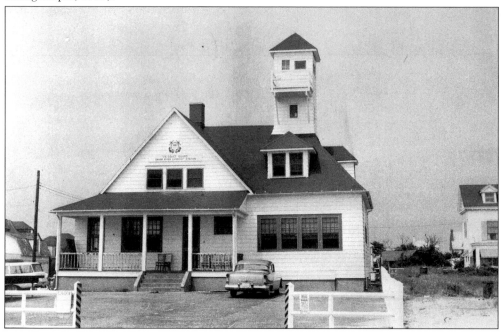

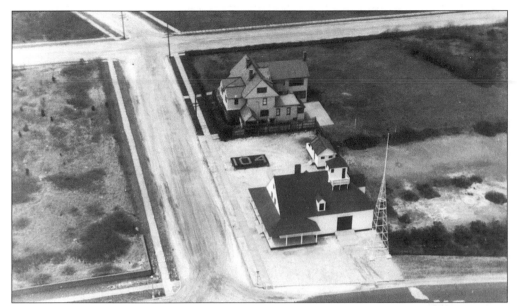

[8] Spring Lake Station, CG 104, still stands about 2.5 miles south of Shark River in Spring Lake (once called Wreck Pond). The first station was probably erected in 1849 and was closed in 1947. Its keepers were Stephen Newman (1849), Samuel Ludlow (1862), H.L. Howland (1879), Joseph Shibla (1886), Andrew Longstreet (1904, transferred to Squan Beach), George W. Hennessey (1904), and William Osborn (1905, still serving in 1915).

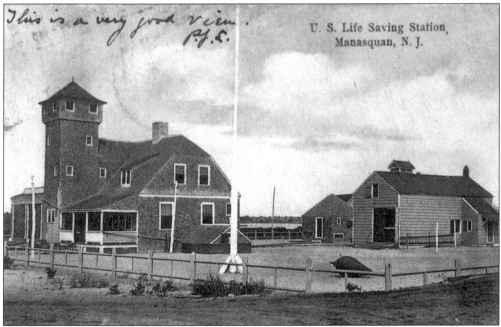

[9] Manasquan Station (Squan Beach), CG 105, is seen in 1915. It was a mile southeast of Squan Village in Manasquan. The 1893 building is now the East Manasquan Coast Guard Station, an electronics facility. The First station was built in 1856. Keepers included David S. Hansinger (1856), E.H. Jackson (1868), William E. Jackson (1875), Robert Longstreet (1879), and Andrew Longstreet (1904, still serving in 1915).

97

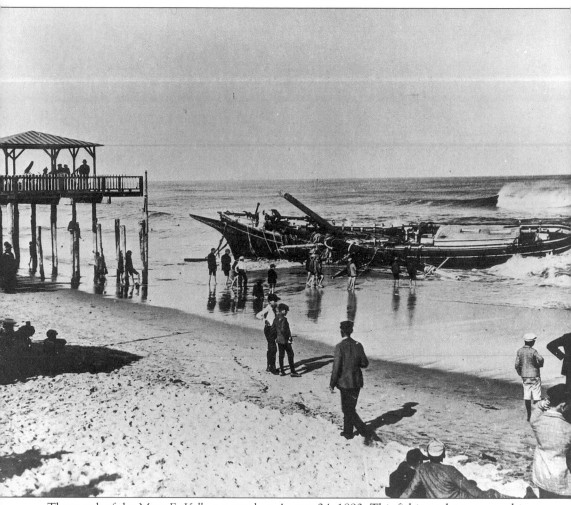

The wreck of the *Mary F. Kelly* occurred on August 24, 1893. This fishing schooner was driven ashore by a severe storm onto Manasquan's beach after initially stranding on the outer bar. Four crewmen drowned, and lifesavers from the Squan Beach Station rescued seven others. Wrecks of this size were typical. Large ships with several hundred people in danger were the well-publicized exceptions. (Mariners' Museum, Newport News, Virginia.)

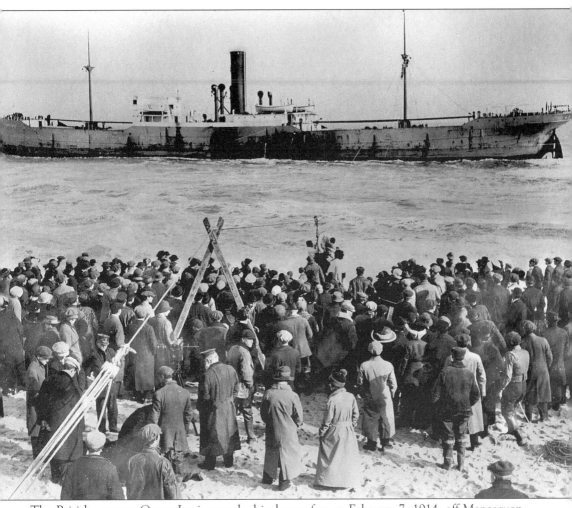

The British steamer *Queen Louise* wrecked in heavy fog on February 7, 1914, off Manasquan. Before modern navigation devices such as radar, Loran, and GPS, steamships, as well as sailing vessels, ran aground on the outer bar along the state's coast. Crowds gathered to watch a breeches buoy being erected. Lifesavers stayed on the beach until February 10, when the vessel was refloated. The ship then headed under its own power toward New York City. There were no deaths. (Mariners' Museum, Newport News, Virginia.)

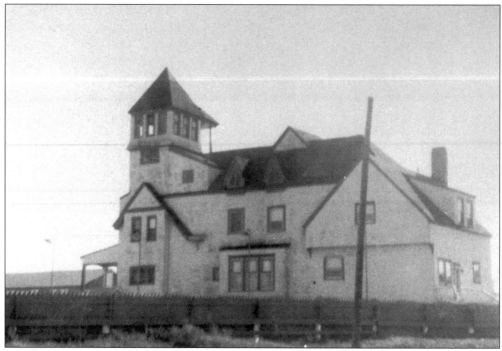

[10] Bay Head Station, CG 106, before 1882 was called Point Pleasant Station. It is situated at the head of Barnegat Bay. The first station was built in 1856 and was closed in 1946. Its keepers included William H. Forman (1856), John C. Clayton (1866), David Flemming (1875), Thompson B. Pearce (1886), and Abner R. Herbert (1909, still serving in 1915).

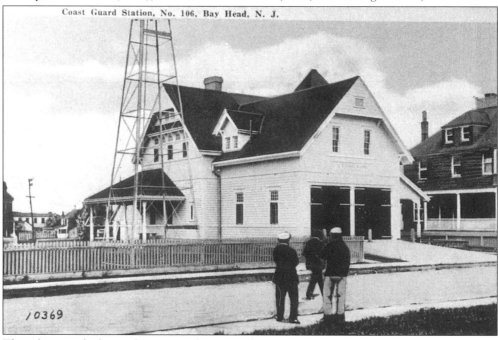

This photograph dating from 1900 shows another view of the Bay Head Station, which was designed by Paul J. Pelz. (Ocean County Historical Society.)

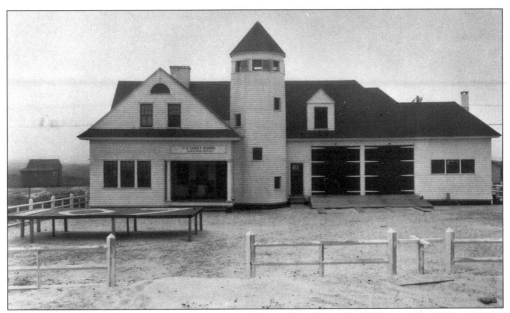

[11] Mantoloking Station, CG 107, was 2.5 miles south of Bay Head. Previously, Mantoloking was called Swan Point. The station was built in 1872 and operated until 1953. Some of the keepers included James Numan (1872), John L. Dorsett (1874), Wesley J. Pearce (1876), Lewis Truex (1880), Abner R. Herbert (1894), and Howard Horner (1909).

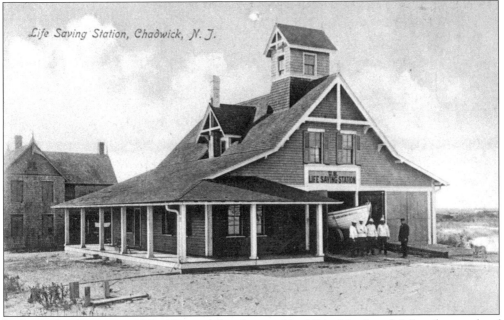

[12] Chadwick Station, CG 108, sits 5 miles south of Bay Head and 2.5 miles south of Mantoloking. This station was earlier called Green Island and still exists. The first station was built in 1849 and was closed in 1939. Keeper William P. Chadwick won a gold lifesaving medal for bravery at the wreck of the *George Taulane* in 1885. Other keepers included John Maxon (1849, a famous wreck master), William Chadwick (1868), Israel I. Hoffmire (1886), John W. Petit (1887), William A. Osborn (1904), and William S. Simpson, (still serving in 1915).

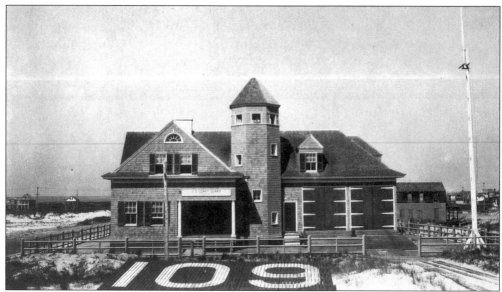

The above photograph shows [13] Toms River Station, CG 109, as it appeared in 1928. The station stood by the mouth of Toms River in Seaside Park (now Seaside Park Borough Hall). The first station was built in 1854, and a new station was constructed in 1872. It closed in 1964. Its keepers included Samuel Chadwick (1856), William H. Miller (1867), Stephen Bills (1876), William H. Miller (1879), William E. Rogers (1893), Henry Ware (1902), and David B. Bowen (1910). The view below shows the station c. 1950, with the watchtower on the beach.

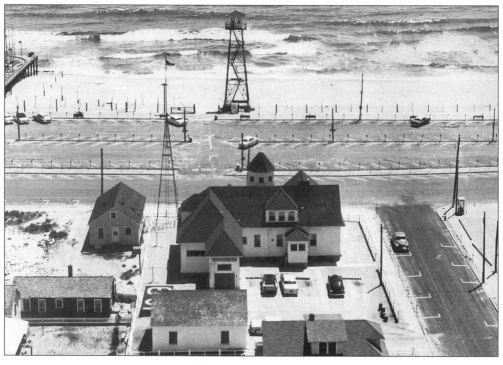

[14] Island Beach Station, CG 110, stood 1.25 miles south of Seaside Park. It remains today in Island Beach State Park. The first station was erected in 1849 as one of eight original stations and was moved twice. This station was inactive in 1938, under the care of Toms River, and it closed in 1946. Its keepers included F. Rogers (1849), Phineas Potter (1856), Joseph Reed (1870), William E. Miller (1895), Joel P. Hulse (1902), (still serving in 1915).

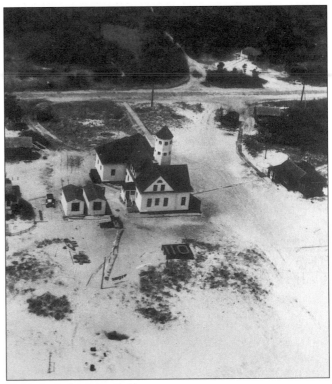

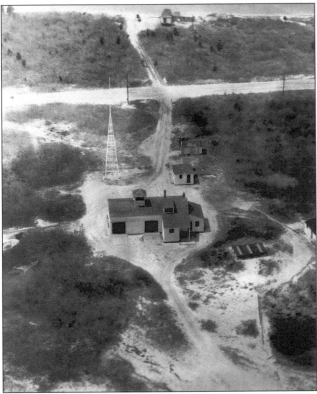

[15] Cedar Creek Station, CG 111, is more than 5 miles north of Barnegat Inlet (today's Island Beach State Park). It operated from 1872 to 1938. In 1920, with one enlisted man in charge, it was considered an auxiliary to Island Beach. The station, although authorized in 1854, does not appear to have been built until 1872. The keepers included John A. Allen (1856), David Herring (1868), Redin N. Penn (1877), Alexander Brinley (1884), Oscar Brinley (1903), David Bowen (1907, until transferred in 1910 to Toms River), and Henry Ware (1910, still serving in 1915). The station was designed in the Jersey pattern.

103

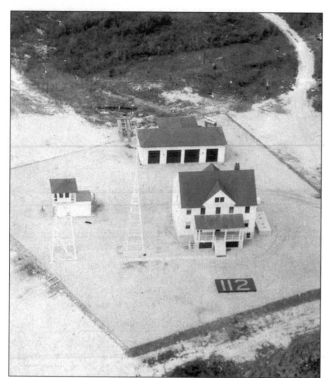

[16] Forked River Station, CG 112, is 2 miles north of Barnegat Inlet, (now Island Beach State Park). The first station on this site was built in 1855 and closed in 1947. The keepers included John Parker (1872), Henry F. Chambers (1876), Allen Allgor (1879), David L. Yarnell (1886, until transferred in 1905), George M. Blackman (1906, until transferred to Ocean City in 1911), and Martin McCarthy (1911, still serving in 1915).

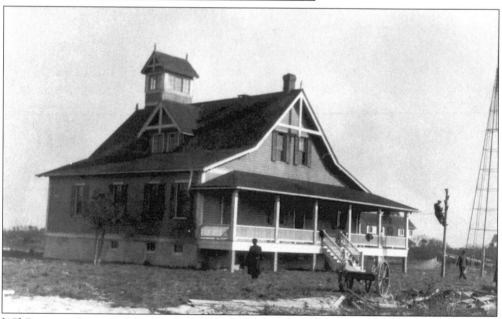

[17] Barnegat Station, CG 113, shown in 1927, was on the south side of Barnegat Inlet in the town of Barnegat Light. It was built c. 1855 on land for which the United States had no title. The station was rebuilt in 1872 and still operates. Although the 1939 building remains, no period buildings still stand. Today's buildings date from 1972. The station site was shifted several times. Its keepers included Joseph Brown (1856), Samuel Perrine Jr. (1872), Joel H. Ridgeway (1878), and Cornelius D. Thompson (1899).

[18] Loveladies Island Station, CG 114, is 2.5 miles south of Barnegat Inlet, in Loveladies. Although it still exists, it was closed in 1922. Originally authorized in 1854 (with a new building added in 1871), the station was called an auxiliary to Barnegat in 1920. Its keepers included Charles Cox (1872), Christopher J. Grimm (1876), and James Cox (1897, still serving in 1915).

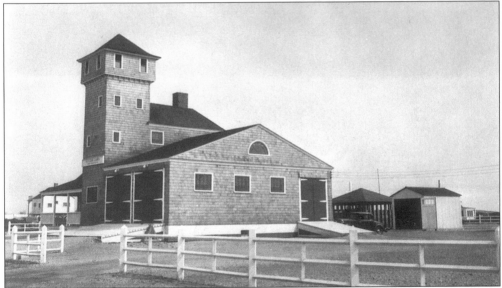

[19] Harvey Cedars Station, CG 115, is more than 5 miles south of Barnegat Inlet. It now houses the LBI Fishing Club. It was built in 1849 as one of the original eight stations authorized in 1848. It was rebuilt in 1872 and again later. In 1938, the station was listed as inactive and was under the care of Ship Bottom Station. In 1950, the site was abandoned. The keepers included Samuel Perrine (1849), Warner Kinsey (1869), Charles Martin Jr. (1873), Benjamin F. Martin (1876), Samuel Perrine (1879), John Kelly (1883), Charles G. Crane (1886), Hudson Gaskill (1888), and Alexander Falkenburg (1901, still serving in 1915). The station was designed in the Duluth style.

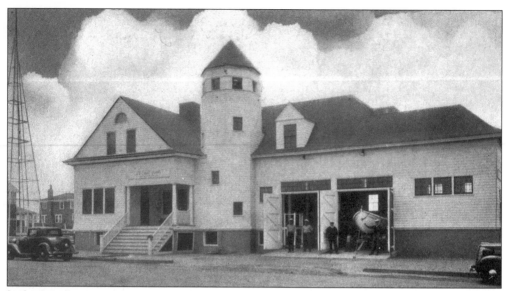

[20] The Ship Bottom Station, CG 116, was one of the original eight stations authorized in 1848. Built in 1849, the station was rebuilt in 1872 and was moved in 1936. The old site was turned over to General Services Administration that year for disposal. There was a Ship Bottom Station until October 1950. Its keepers included Edward Jennings (1856), Henry Lamson (1872), George W. Crane (1874), John N. Truex (1879), and Issac W. Truex (1896, still there in 1915).

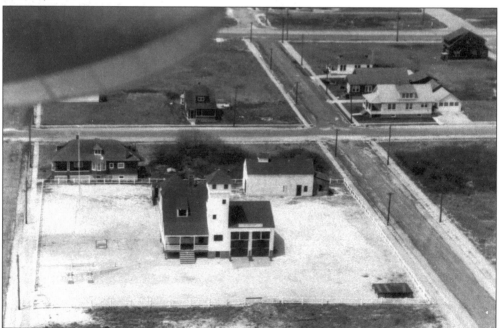

[21] Long Beach Station, CG 117, is shown here in 1940. Still standing, the property was abandoned in 1946. The station was built in 1849. In 1871, it was rebuilt and shifted to another site. It was rebuilt again c. 1893. By 1938, the station was listed as inactive, under the care of Ship Bottom Station. The keepers included William H. Crane (1872), George Sprague (1877), James Sprague (1881), and Frank M. Sprague (1912, still serving in 1915).

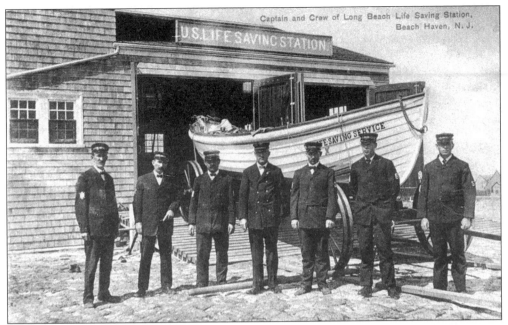

The Long Beach crew appears in this *c*. 1912 postcard.

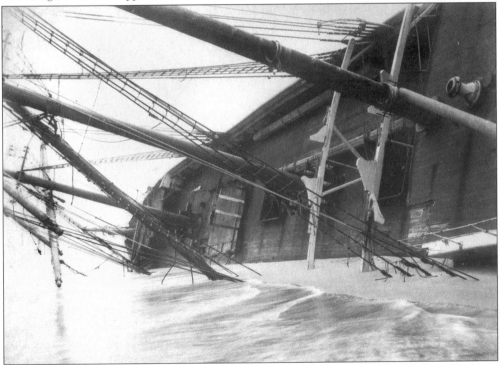

The bark *Fortuna* wrecked near Beach Haven on Long Beach Island on January 18, 1910. Although this was a significant wreck, New Jersey lifesavers suffered their greatest loss with the wreck of the *Kraljevica* off Barnegat on February 11, 1886. In their attempts to rescue this ship, three surf men died after their boat overturned in heavy surf. (Ocean County Historical Society.)

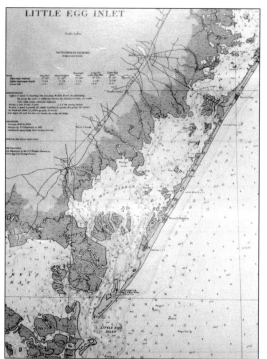

This 19th-century chart shows Long Beach Island and the adjacent mainland. Note that what later became Tucker's Island is still attached to the southern end of Long Beach Island.

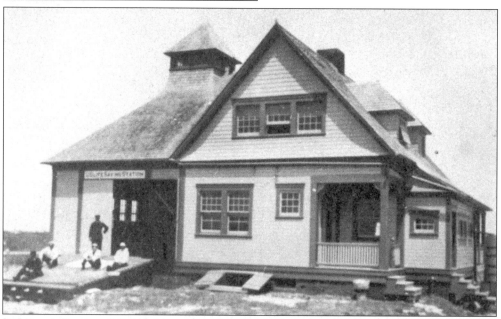

[22] Bonds Station, CG 118, is just over 2 miles south of Beach Haven. Shown here c. 1900, the station was built in 1849, rebuilt and enlarged in 1872, and moved to new site in 1886. In 1896, it was moved again because of encroaching seas. A 1962 storm inflicted such severe damage on the the station that it was moved and a new station was erected in Beach Haven. It still operates as a seasonal station. Over the years, it has had keepers who included Thomas Bond (1849), Lewis Steward (1853), Thomas Bond (resuming his charge in 1866), John Marshall Jr. (1883), and Samuel E. Holdzkorn (1909).

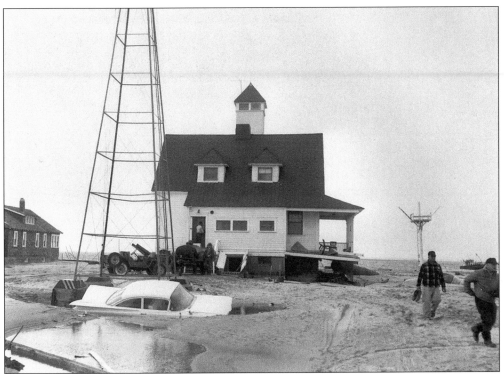

A 1962 storm caused severe damage to Bonds Life-Saving Station, which was then rebuilt at its new site in Beach Haven. Bonds was originally constructed in 1898, and a new station was finished in February 1964. It also replaced Little Egg Station, which moved to the mainland after Tucker's Island disappeared beneath the waves.

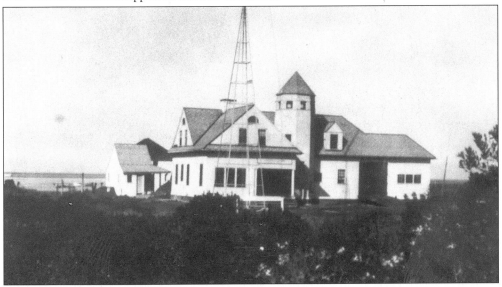

[23] Little Egg Station, CG 119, is located north of Little Egg Inlet on Tucker's Island. The first station on this spot was built in 1856. The early 1900s building shown here was swept into the sea in 1927. Early keepers included Thomas W. Parker (1856) and Jarvis Rider (1869, still serving in 1915). Rider's brother was the Tucker's Beach Lighthouse keeper.

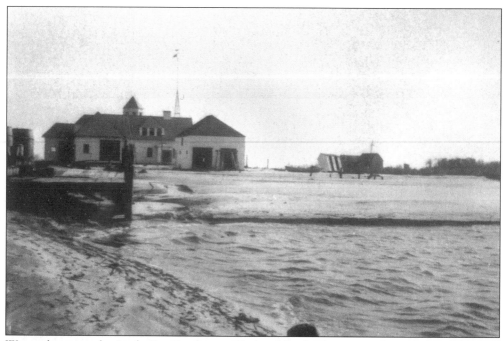

Water threatens the Little Egg Station on Tucker Island. The station kept its name but was moved to the mainland with a Tuckerton address.

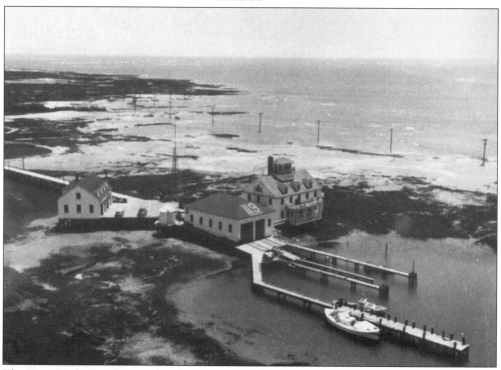

The New Little Egg Station (in the Coast Guard era) is in the style of 1936–1940 buildings. Other Coast Guard facilities built in this distinctive style include Manasquan, Barnegat, Longport, Atlantic City, and Hereford Inlet.

[24] Little Beach Station, CG 120, is on the south side of Little Egg Inlet, north of Brigantine. As one of the original eight stations, it was built in 1848 and was closed in 1936. The station was moved because of encroaching seas and was rebuilt in 1872. In 1894, the station was given a new site and new building. Some of its keepers were Joseph P. Shourds (1872), William F. Gaskill (1873), Major B. Ireland (1881), Charles H. Horner (1884), James Rider (1890 until transferred to Great Egg Station in 1898), Alexander Falkinburg (1898 until transferred to Harvey Cedars in 1901), Joseph H. Riley (1900), and Thomas Endicott (1905, still serving in 1915).

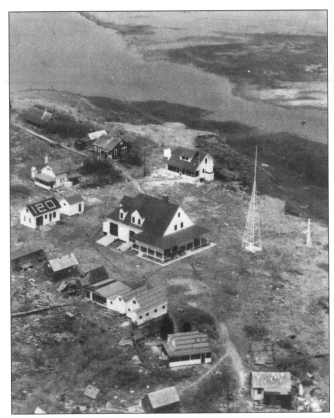

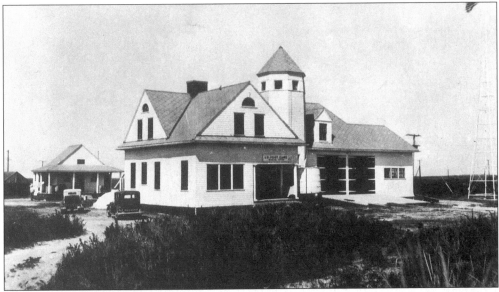

[25] Brigantine Station, CG 121, is over 5 miles north of Absecon Lighthouse. It was built in 1849 and was moved several times. Severe damage resulted from both the 1888 storm and the hurricane of 1944. In 1948, the station closed. Its keepers included Thomas Clark (1853), James Scull (1856), William Holdzkorn (1862), John H. Turner (1876), Constant Bowen (1884), James A. Abrams (1887), and John M. Holdzkorn (1895, still serving in 1915).

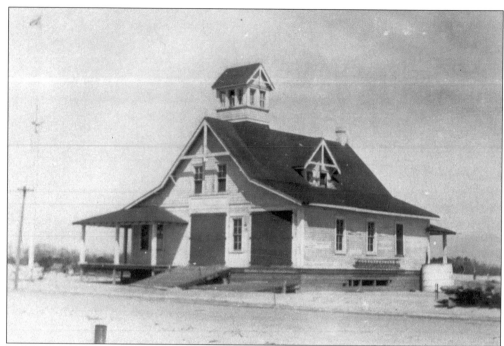

[26] South Brigantine Station, CG 122, was 1.25 miles north of Absecon Lighthouse. The station was built in 1872 and closed in 1933. Early keepers included Charles A. Holdzkorn (no date available), William Holdzkorn (1883), Lambert Oaker (1900), and Frank Smith (1903, still serving in 1915).

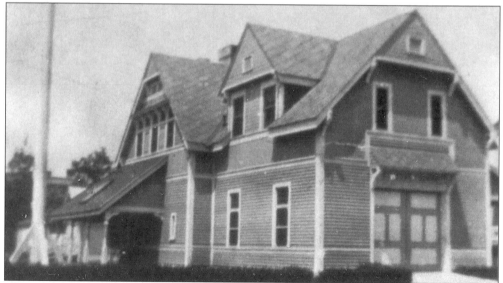

[27] The Atlantic City Station, CG 123, is shown in this 1915 photograph at Absecon Light. It was built in 1849 and moved several times. The station still exists as a facility built between 1939 and 1941. In 1884, a larger station was built at the base of lighthouse. Its keepers included Ryan Adams (1853), Samuel Adams (1856), Barton or Burton Gaskill (1862), Purnell Brown (1876), Amasa Bowen (1879), Timothy H. Parker (1893, until transferred to Absecon in 1905), and Lambert Oarker (1905, still serving in 1915).

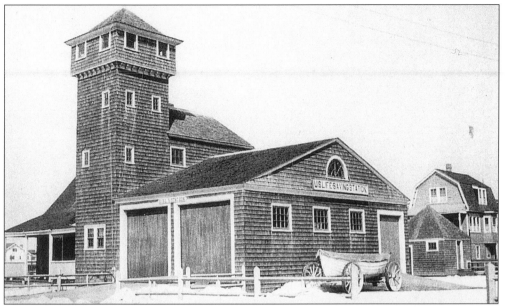

[28] Absecon Station, CG 124, stood 2 miles south of Absecon Light in Atlantic City on Annapolis Avenue. The station was built in 1872 and rebuilt in 1896. By 1917, it was considered an auxiliary station to Atlantic City and was closed in 1922. Keepers included Thomas Rose (1872), William W. Eldridge (1876), Israel L. Blackman (1879), Joseph L. Glaskill (1885), Aaron B. Steelman (1899), and Timothy B. Parker (1905, still serving in 1915).

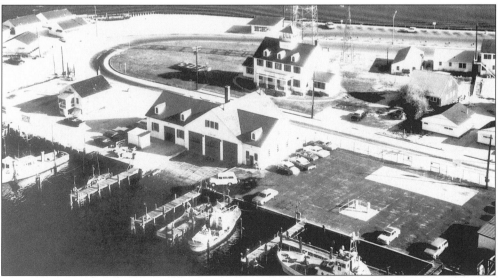

[29] Great Egg Station, CG 125, stands 6 miles south of Absecon Lighthouse in Longport. By the water is the station from the Life Saving Service era. The building in the background dates from 1938. The station, moved at least twice in its lifetime, was originally built in 1849 and closed in 1947. The 1938 Coast Guard building is now a small museum and headquarters for the Longport Historical Society. Keepers included Joseph Ireland (1856), John Bryant (1862), William Smith (1876), Levi P. Casto (1877), James Rider (1898), Lambert H. Parker (1905, until transferred to Atlantic City), Joseph H. Riley (1905), and Samuel E. Holdzkorn (1915).

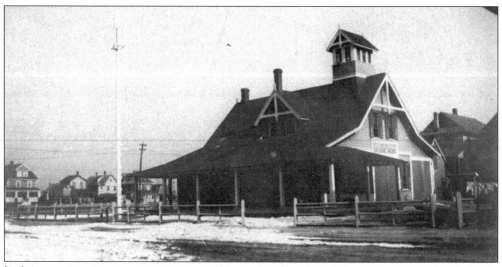

[30] Ocean City Station, CG 126, is on the south side of Great Egg Inlet. Earlier, Ocean City was called Beazley's. Authorized in 1849, the station was not built until 1878. It is unknown whether there was an earlier building; the current facility dates from 1885 and still stands on Fourth Street. At one point, the station was moved from the ocean to the bay side, where a different building is still in operation. Its keepers included Joseph Somers (1853), Richard L. Somers (1856), Richard B. Stiles (1862), Thomas Stiles (1872), J. E. Willetts (1877), John M. Corson (1893), and George M. Blackman (1911, still serving in 1915). This is an 1882-style station.

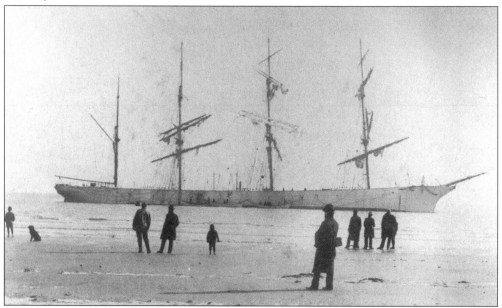

All were rescued from the wreck of the *Sindia* off Ocean City on December 16, 1901. Although lifesavers routinely risked their lives, the service was stingy in awarding medals. Even so, several New Jersey surf men received awards for heroism on duty. On February 3–4, 1880, in Monmouth Beach, the station crew under keeper Charles Valentine rescued passengers and crew from three ships in a blizzard during the same day. Valentine and four surf men were given gold medals. (Friends of Ocean City Historical Museum Inc.)

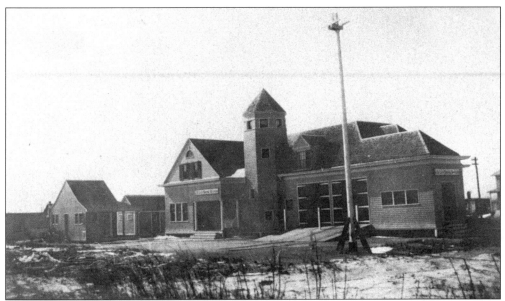

[31] The site of Pecks Beach, CG 127, was south of Ocean City in 1915 but falls within city limits today. It is 8.5 miles north of Corson Inlet. The station was built in 1870 and was replaced in 1898. It was closed in 1922, although it may have been reopened for brief periods. Its keepers included John Stiles (1872), Leaming Godfrey (1879), and Adolphus C. Townsend (1900, still serving in 1915).

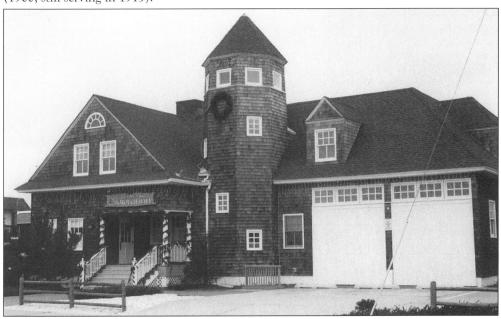

The former Toms River Life-Saving Station, CG 109, has been recycled into the Seaside Heights Borough Hall. The exterior of the building has been well preserved (see page 102, top), and a town has grown up around this once relatively isolated station. New Jersey's 20 or so remaining life-saving stations have been reused in a variety of ways: for Kiwanis and American Legion facilities, as gift shops, as offices, as museums, and as private residences. (Author's photograph.)

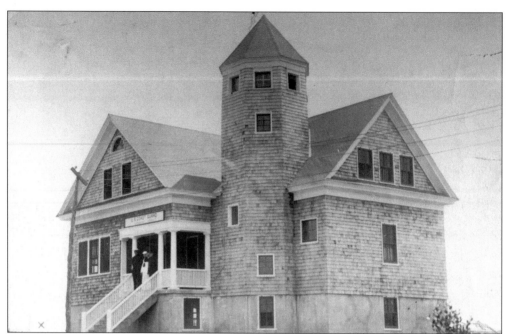

[32] Corson Inlet, CG, 128, appears in this 1925 photograph. The station, located on the north side of Corson Inlet (near the inlet and north of Strathmere), was built in 1849. It was closed in 1964. Records say that the old and inadequate station at Corson's Inlet was replaced in 1898. In 1925, that building was moved across the inlet because of encroaching seas but kept its original name. It still stands today. Some local references call it Strathmere Station, but since there was no station officially called that, it was always known as Corson's Inlet Station. Its keepers included Richard Stiles (1856), Sylvanus Corson (1862, Charles D. Stephens (1883), Reuben S. Godfrey (1897), and Cornelius Nickerson (1908, still serving in 1915).

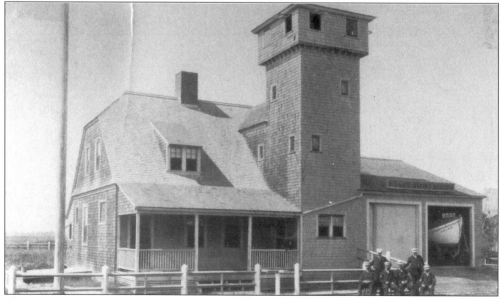

The Corson Inlet station, seen in this 1925 photograph, was moved across the inlet to Strathmere.

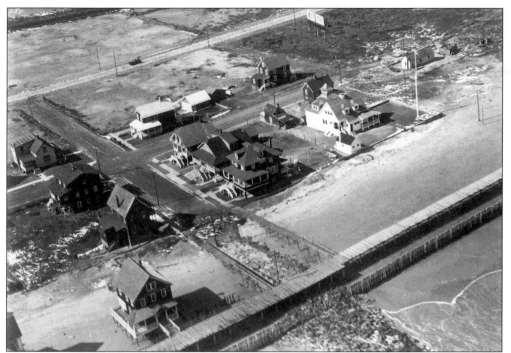

[33] Sea Isle City Station, CG 129, in Sea Isle City (1918) was earlier called Ludlum Beach. It was located 3.25 miles north of Townsend Inlet. The station was authorized in 1849 but may not have been built until 1872. In 1888, a new station was put up, which became inactive in 1936 and closed in 1939. The keepers included David Townsend (1872), John M. Townsend (1875), George Sayres (1877), John S. Cole (1893, until promoted to superintendent of Fifth District in 1912), and Aaron Smith (1912, still serving in 1915).

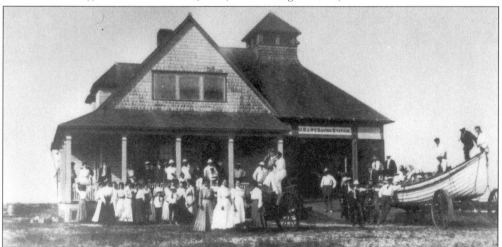

[34] Townsend Inlet, CG 130, was located on the 00north side of Townsend Inlet in 1903. The first station was built in 1849 and rebuilt in 1886. By 1906, the town began to build up around the station and it was moved. Ît is still in operation, with a new facility, as a summer seasonal station. The old station building still exists. Keepers included Platt Brower (1853), Henry Willets (1867), Henry L. Smith (1886), and Benjamin F. Hall (1903).(Cape May Historical and Genealogical Society.)

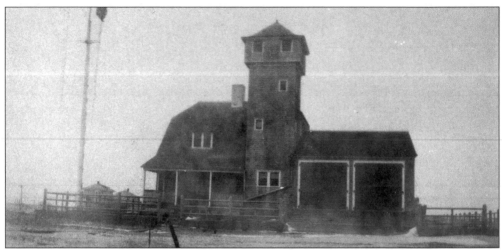

[35] Avalon Station, CG 131, was 3.75 miles southwest of Ludlam Beach Light. Shown here in 1914, the station was authorized in 1882 and built in 1894. In 1938, it was closed although the structure remains standing. Its keepers included John W. Swain (1894, transferred to Stone Harbor) and Frank Nichols (1906, still serving in 1915).

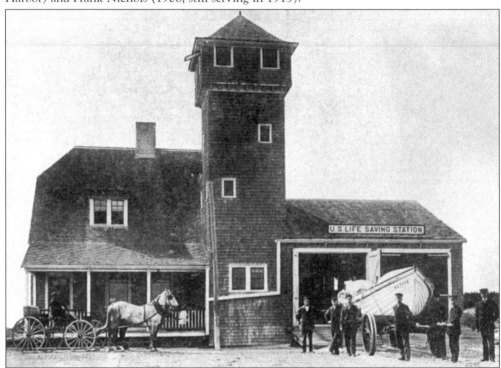

[36] Tathams Station, CG 132, later known as Stone Harbor, is shown here in 1910. It stood 2.25 miles northeast of the inlet in Stone Harbor and still stands today. Built in 1872, the station was authorized in 1854. In 1895, a replacement station was built at a new site because its predecessor was too small. It was closed in 1947. The keepers included H.B. Richards (1856), John W. Gandy (1870), Franklin Hand (1874), Richard C. Holmes (1876), John W. Swain (1888, until transferred to Avalon in 1894), Richard S. Ludlam (1895), and Harry McGinley (1910).

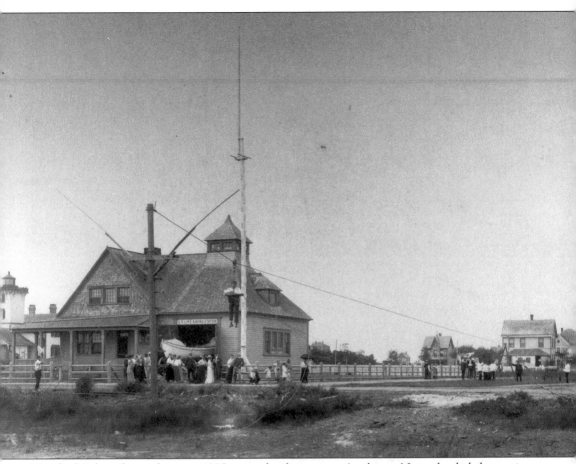

Hereford Inlet, shown here *c.* 1895, was also known as Anglesea. Note the lighthouse in the background and the spectators watching a breeches buoy drill. Drills that were held during the summer months at shore resorts always drew a crowd. Every life-saving station had a practice pole on site. In this case it was a simulation of a ship's mast, adjacent to the corner of the station. Lines were rigged from portable wooden stanchions to the pole, and the breeches buoy was then put in place. (Cape May Historical and Genealogical Society.)

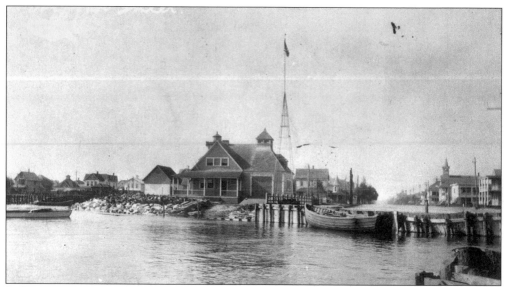

[37] Hereford Inlet Station, CG 133, was near Hereford Inlet Lighthouse (Anglesea). The station was built in 1849 and was moved in 1882 because of the threatening ocean. In 1888, a new station adjoining the lighthouse reservation was built. The building on-site dates from the 1936–1940 period. The station was closed in 1964. Its keepers included John R. Ludlam (1853), Maurice Cresse (1862), Jesse A. Price (1862), Christopher Ludlam (1883), Henry W. Hildreth (1897), and Henry S. Ludlam (1902).

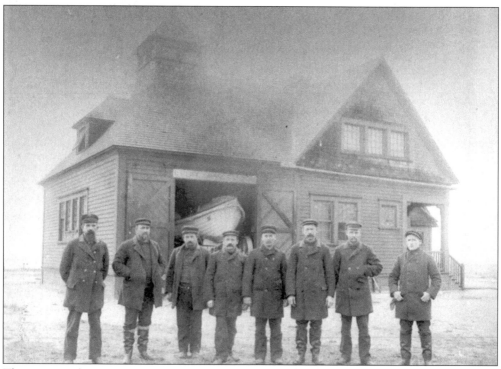

This *c*. 1890 photograph shows the Hereford Inlet crew posing in front of the station.

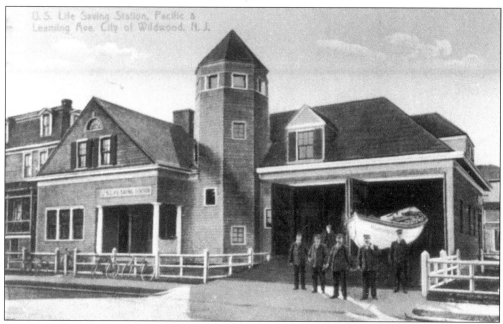

[38] Holly Beach, CG 134, in Holly Beach (Wildwood), was called Turtle Gut until 1883. It was located 6 miles northeast of Cape May City. The first station was authorized in 1854 but may not have been built until 1872. The name of the station was changed because the crew complained of being teased for having Turtle Gut on their new uniforms. A new station was built in 1898, became inactive in 1938, probably reopened during World War II, and finally closed in 1946. Keepers included Elizah Hand Jr. (1877), Frank Downs (1883), and Henry S. Ludlam 1915.

[39] Two Mile Beach, CG 135, is 4 miles northeast of Cape May City. The station was authorized in 1854, although the first station appears in records only after 1872. It was closed in 1925. Some early keepers included Eli Barnett (1872) and Uriah Cresse (1879).

[40] Cold Spring, CG 136, stands a half mile east of Cape May City. It was built in 1868 and rebuilt in 1891. It operated until 1935, and the structure remains. In the past, the Cape May Harbor and Inlet entrances were called Cold Springs. The keepers included George Hildreth (1869), Augustus Sooy (1886), and Richard Cresse. The station is designed in a Bibb No. 2 style.

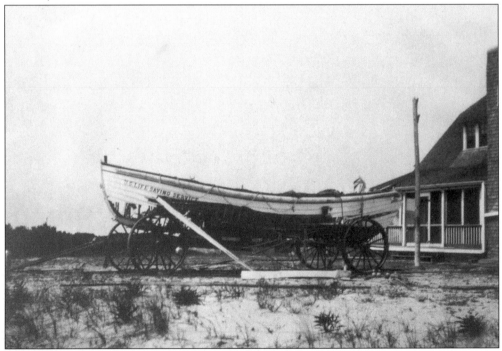

The heavily damaged surfboat illustrates the rigors that lifesavers faced against angry seas. This is a Stone Harbor Station boat in an undated photograph.

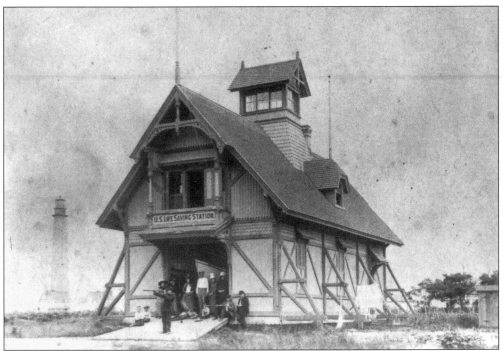

Cape May Station, seen above in 1876, was designed by architect J. Lake Parkinson. It was part of the U.S. Life-Saving Service's exhibit at the 1876 Philadelphia Centennial. This was a modified version of the basic 1876-style station. About 26 such stations were built, with at least three of those in New Jersey. The photograph below shows Cape May Station being modified to serve as a storage facility after a newer facility had been built at Cape May Point. (Mid-Atlantic Center for the Arts.)

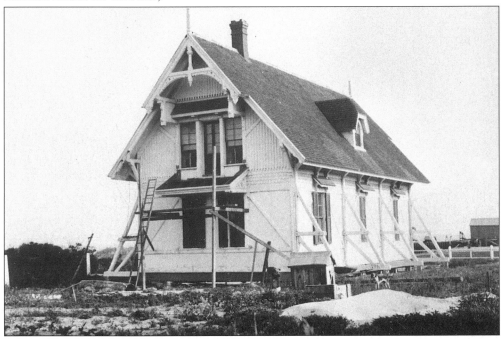

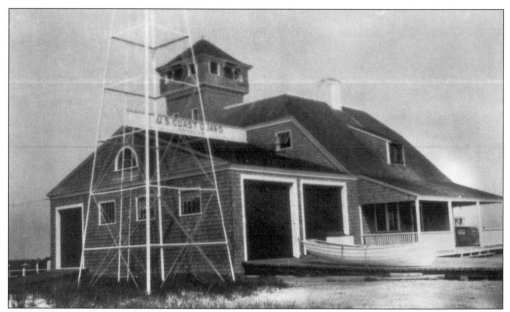

[41] Cape May Station, CG 137, was at the lighthouse in Cape May Point. The station was built in 1849 and was moved several times over the years, as seas encroached. It was replaced in 1896 and operated until 1948. Today, there is a rescue unit at the Coast Guard Training Center in Cape May. The old site was drowned by the ocean in the early 1960s. Cape May Station's keepers included Lewis Stevens (1853), Christopher Leaming (1856), George Hildreth (1869), and Charles H. Hand (1877).

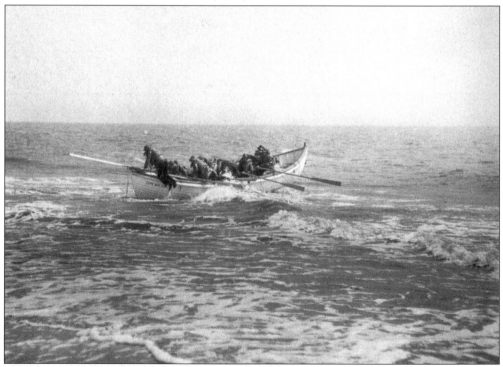

This 1935 photograph shows the Cape May Point boat crew in the Coast Guard era.

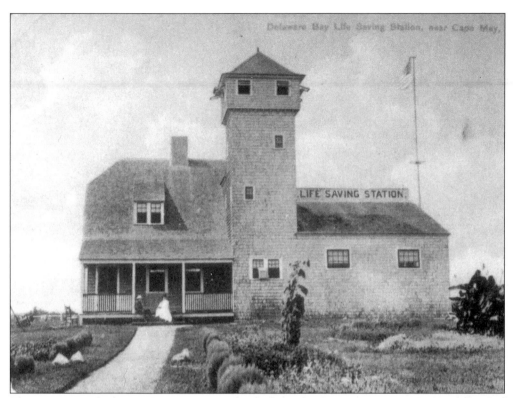

This station on the bay in Cape May near the dock for the Cape May–Lewes Ferry only existed for a few years. It was known as station 42 in New Jersey, although boats and rescue gear were stored there under control of the Cape May Station. The bay-side station was about 3 miles from station 41, next to the lighthouse. (T.J. MacMahon.)

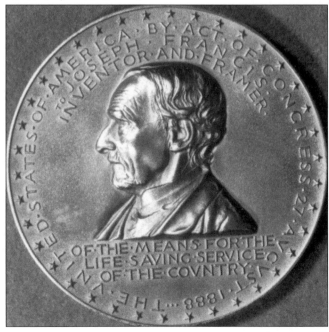

In 1888, Joseph Francis, a Toms River resident, was honored by Congress with this medal for inventing the life-car rescue device. A controversy arose after Revenue Service Capt. Douglas Ottinger (see page 77), claimed to have invented the life-car, which he called a surfcar. Evidence favors Francis, who was awarded the life-car patent and who Sumner Kimball said was the inventor.

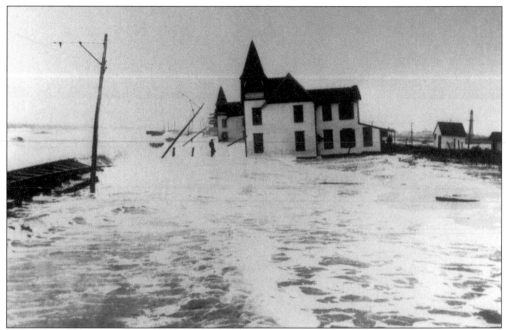

This early 1940s scene shows what happened to the community of South Cape May, which existed near the lighthouse. The nearby life-saving station met the same fate about 20 years later. (Mid-Atlantic Center for the Arts.)

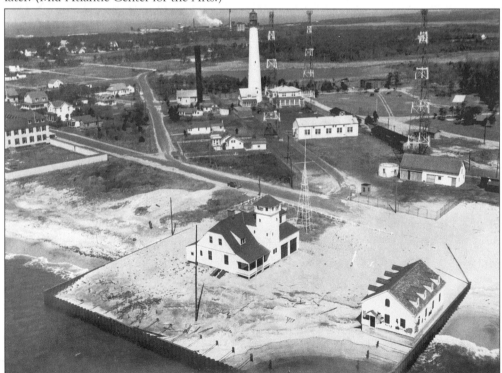

The life-saving station shown in this late 1950s or early 1960s photograph was washed into the sea in the early 1960s, although it had been closed before it disappeared under the waves.

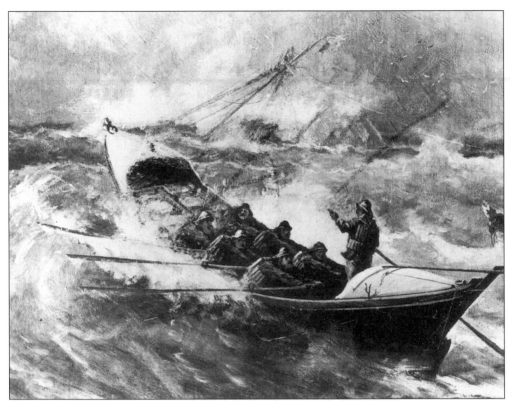

The era of "iron men and wooden ships" is long gone. The men and the ships have slipped into history. Some of their buildings remain as reminders of them, but even their own service treats them as a largely forgotten legacy. For a brief period, the men of the U.S. Life Saving Service were heroes of the beach and warriors against the storm. Most of their stations were closed, according to Robert Bennett, a retired Coast Guard officer, because "modern communications, new navigational aids, helicopters, [and] fast patrol boats from Coast Guard stations provide a more efficient system of safeguarding life and property along the beaches"—more efficient, perhaps, but certainly not more picturesque. The motto of today's Coast Guard reflects some of the lifesavers spirit: *Semper Paratus*, "Always Ready."

BIBLIOGRAPHY

Bennett, Robert. *Sand Pounders*. Washington, D.C.: U.S. Coast Guard Historians Office, 1998.

Flint, Willard. *A History of U.S. Lightships* Washington, D.C.: U.S. Coast Guard Historians Office, 1989.

Gowdy, Jim, and Kim Ruth. *Guiding Lights of the Delaware River & Bay*. Sweetwater, NJ: Jim Gowdy Publisher, 1999.

Holland, Ross. *America's Lighthouses: An Illustrated History*. Garden City, NY: Dover Publications, 1985.

National Archives. Files and photographs pertaining to U.S. Lighthouse Service, U.S. Life-Saving Service, and U.S. Coast Guard. Washington, D.C., and College Park, MD.

Putnam, George. *Lighthouses and Lightships of the United States*. Boston: Houghton Mifflin, 1918.

U.S. Life-Saving Service. Annual Reports, Washington D.C.: Government Printing Office, 1876–1914.

U.S. Lighthouse Service. Annual Reports. Washington, D.C.: Government Printing Office, various years.

York, Wick, and Ralph Shanks. *The U.S. Life-Saving Service*. Petaluma, CA: Costano Books, 1998.

For further information:

New Jersey Lighthouse Society
P.O. Box 4228
Brick, NJ 08723
Internet address: www.njlhs.burlco.org

U.S. Lighthouse Society
Fifth Floor
244 Kearny Street
San Francisco, CA 94108
Internet address: www.cheslights.org

U.S. Life-Saving Service Heritage Association
P.O. Box 75
Caledonia, MI 49316-0075
Internet address: www.uslife-savingservice.org